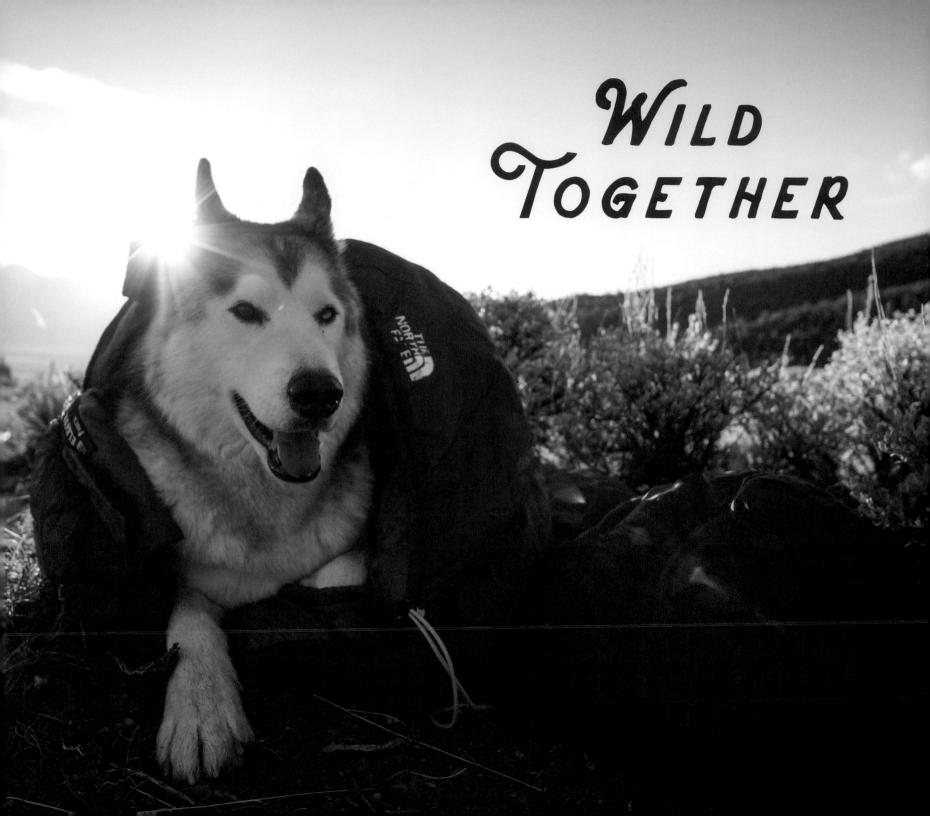

WILD
TOGETHER

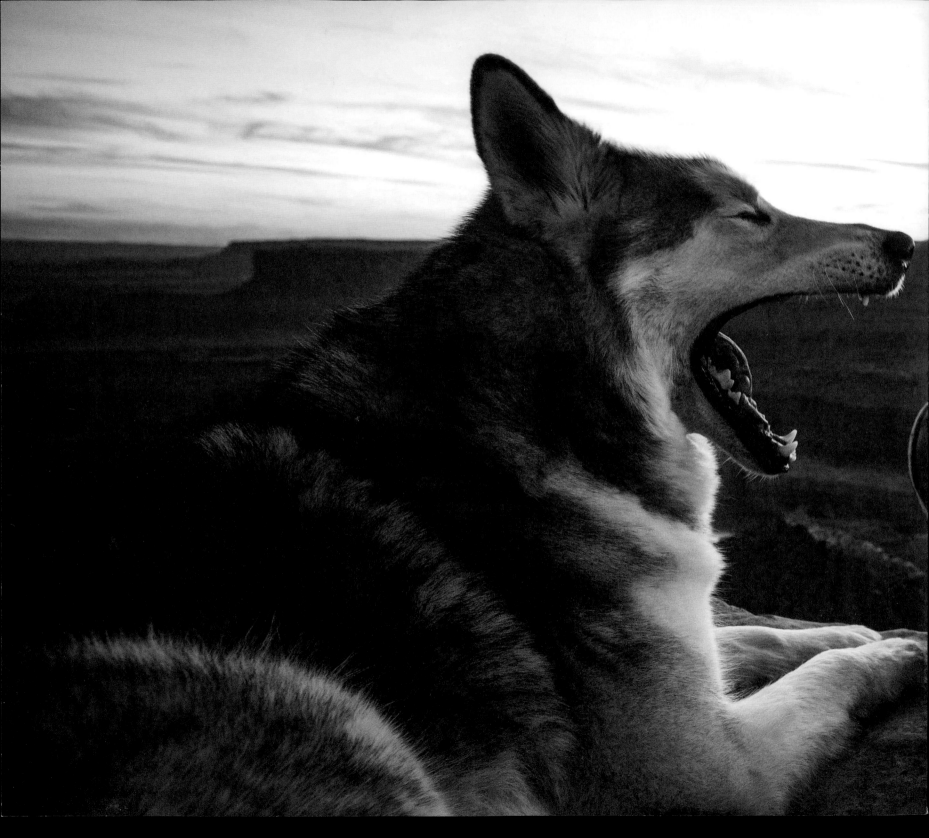

WILD TOGETHER

MY ADVENTURES WITH LOKI THE WOLFDOG

KELLY LUND

WITH ALLY COUCKE

PEGASUS BOOKS

NEW YORK LONDON

WILD TOGETHER

Pegasus Books Ltd.
148 W. 37th Street, 13th Floor
New York, NY 10018

First Pegasus Books edition July 2018

Interior design by Maria Fernandez

Photography by Kelly Lund with special help from Jon Jenkins, Nate Grimm, Travis Lund, and Ally Coucke.

Library of Congress Cataloging-in-Publication Data is available.

ISBN: 978-1-68177-769-6

10 9 8 7 6 5 4 3 2 1

Printed in the United States of America
Distributed by W. W. Norton & Company, Inc.
www.pegasusbooks.us

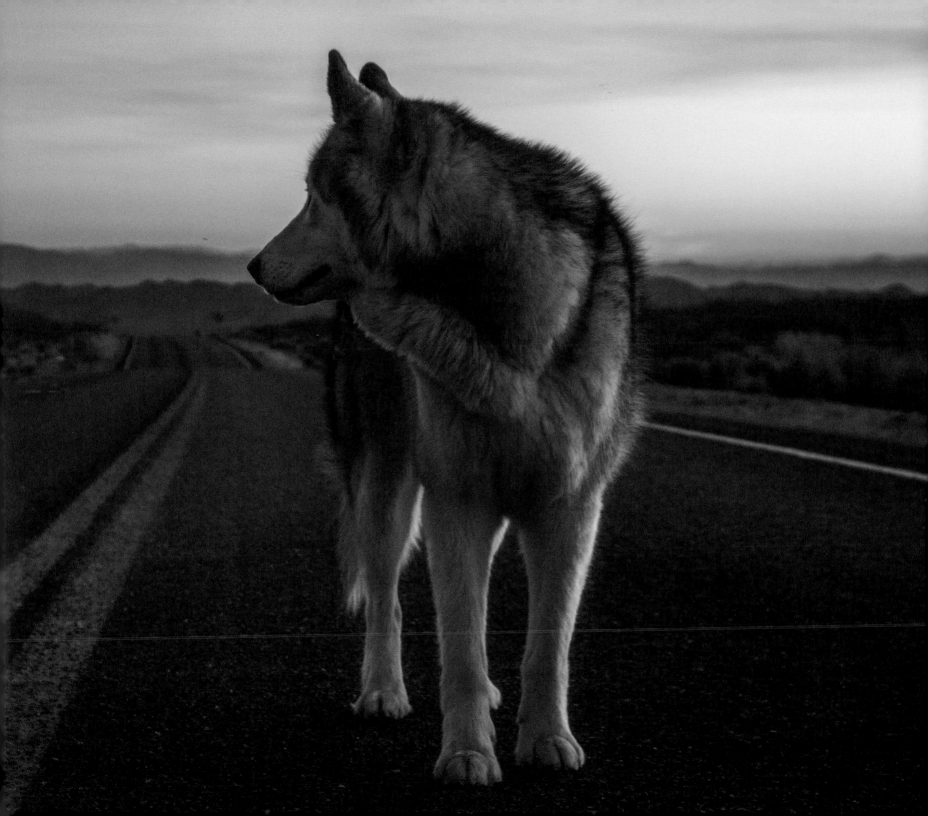

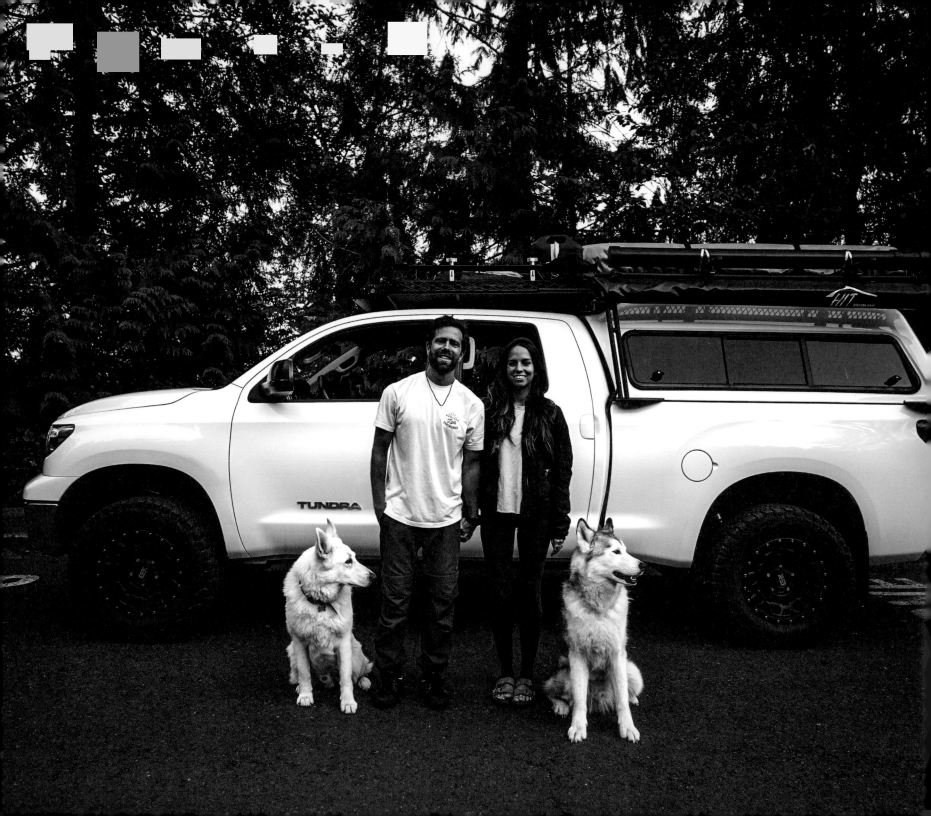

INTRODUCTION

I don't know if we are driving in the right direction.

The road doesn't look familiar, cell service is lost, and we are running out of daylight.

I look over my shoulder and see Loki sleeping with not a care in the world.

It slowly washes over me, and I let it; it doesn't really matter.

It doesn't matter where we end up or when we get there. We are together.

Kelly Lund is a professional dog dad, photographer, and avid outdoorsman. His trusty companion, Loki, is an Instagram sensation but has yet to realize it. Together, Kelly and Loki roam the country and take photos of their journey along the way. While they reside in Denver, Colorado, they are rarely seen there, outside of repacking the truck before charging off on their next adventure.

Along the way, they have captured memories and stories for a lifetime. They also picked up a couple of tag-a-longs: Ally Coucke and her dog, Bailey. While traveling around North America, the duo has curated photos and writings about travel, the outdoors, and the love of a dog. Kelly and Ally share a love of adventure, wanderlust, their dogs, and each other.

To explore this Earth is such a marvelous ride, and the journey with a dog next to you can be hard to put into words. Kelly's mission is to show the world that a dog can go where you go; he doesn't need to be left behind. You truly can go into the wild, together.

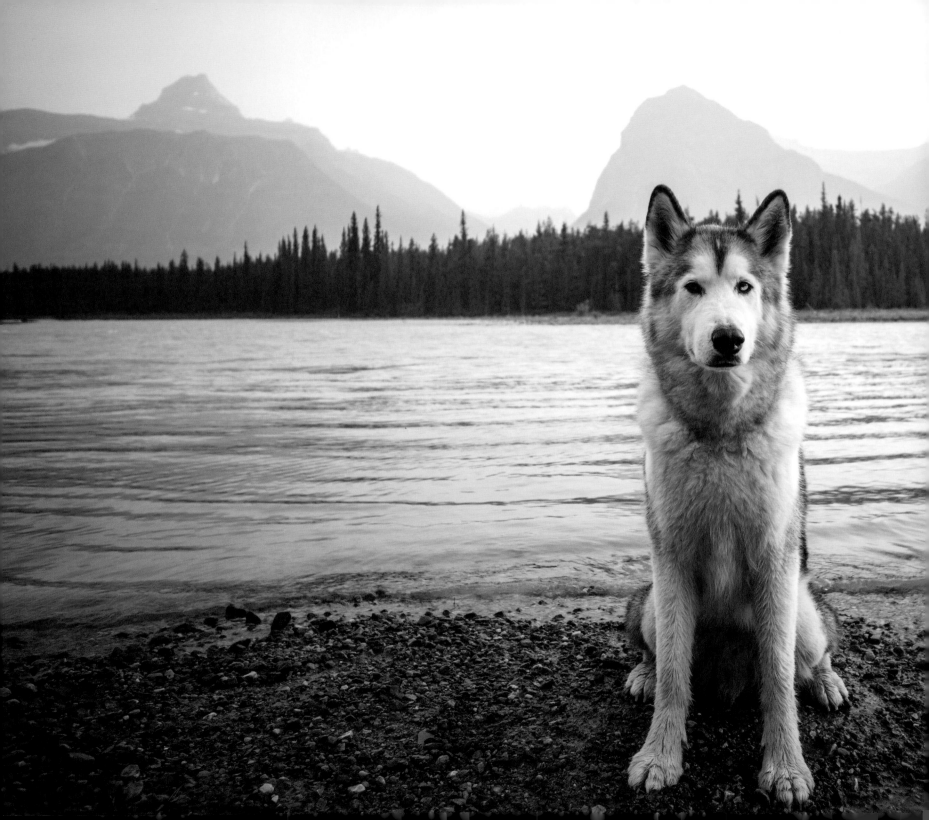

DISCOVERY

I want to go to a place I've never been before. I want to meet it like a new friend. I want to learn its best attributes, and explore the heights within that. I want to know the dark parts that don't really matter because the good shines too brightly.

Let us drive until the road signs disappear and become a distant memory. Come with me, and let us push the limits on this treasure hunt that is life.

To Have and To Own

I really don't like saying the phrase, *I own a dog*, because honestly, what right do I have to do such a thing?

Dogs are not simply possessions to be had. It is not our right to chain them up, lock them in rooms or cages, or keep them under any sort of lock and key. It has to be a gray area, where we get to keep them, and they get to keep us. Yes, we set boundaries and guidelines, such as leashes and certain protocols. We can argue that it stems from love and caring for the animal's wellbeing, but at the end of the day, we can't own them.

Loki's mind and body belong to him. I, as his human, chose him, and he, as a dog, seemingly has chosen to stay with me. We do know that his species communicates far beyond human interactions, and I promise you, they know things we don't.

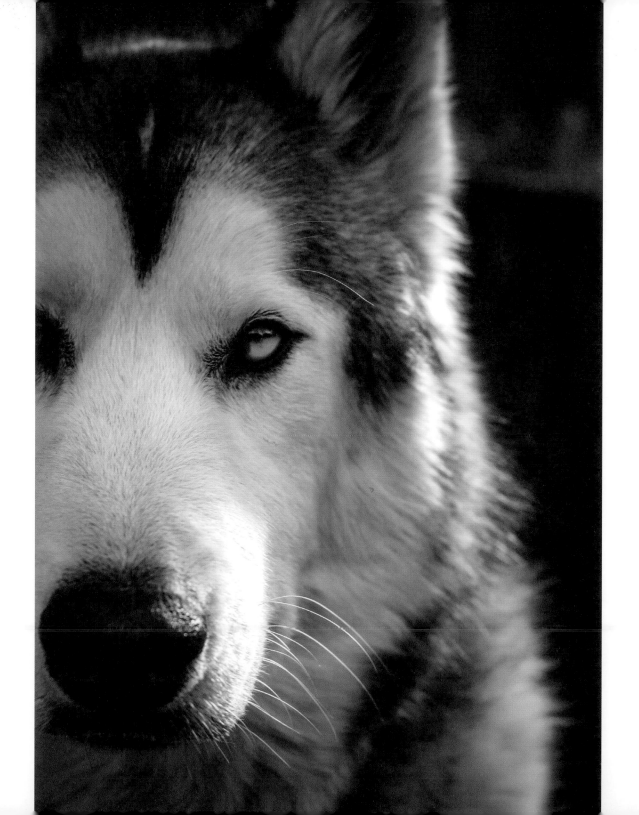

Denver, Colorado

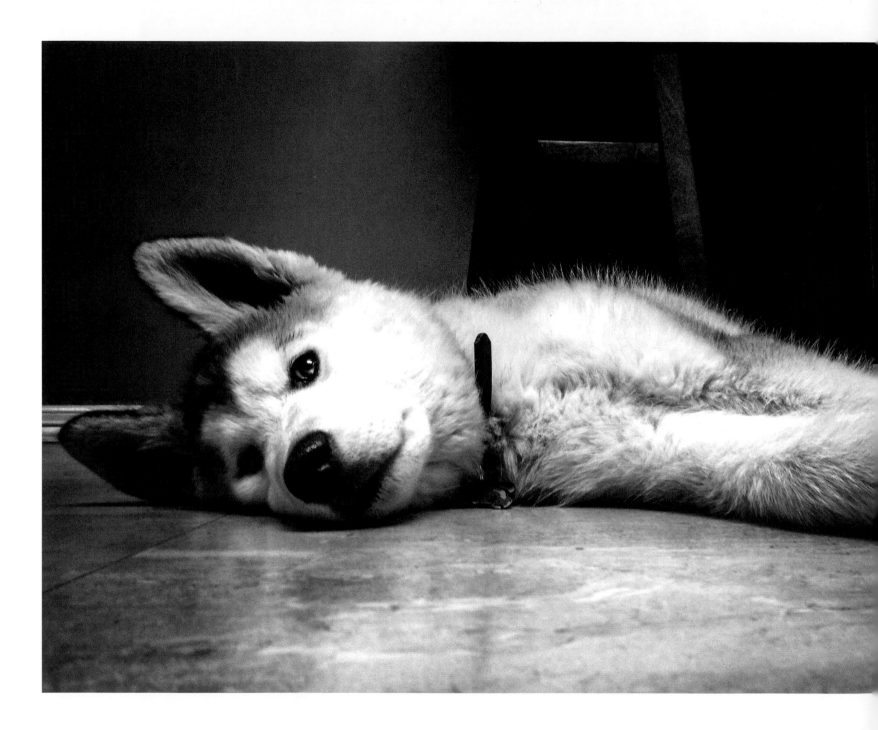

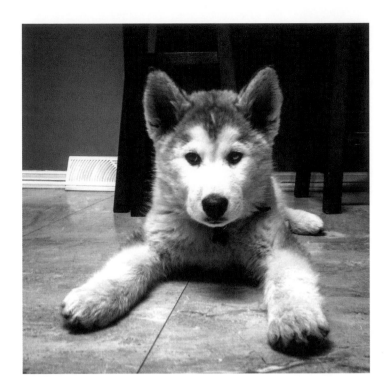

Old Friends

An undeniable fact: there isn't a heart on this planet that can't be melted by a fuzzy eight-week old puppy. They have a power over you that makes you want to stay home from plans with friends and go for walks in the park by your house that you've never been to before. You bounce around with a spring in your step feeling so excited about all the possibilities.

When the novelty fades, you are now staring at an adult dog. As the years continue to pass, the little changes you notice will tightly grip your heart. The soft gray hair appearing around his eyes, his pace slowing on your runs, and his stretches become more labored. The only thing that hasn't changed is his love for you, nor yours for him.

Nothing can compete with that love; it has been earned.

Ends of the Earth

After all the places we have been, we know there is more. We know we have to keep going, and we have to keep looking for the unseen.

 Loki is my challenge every day. I look at him, and I want to feel how he does. He is always ready, he is always on that level I strive to be on. I know without him I wouldn't go as far.

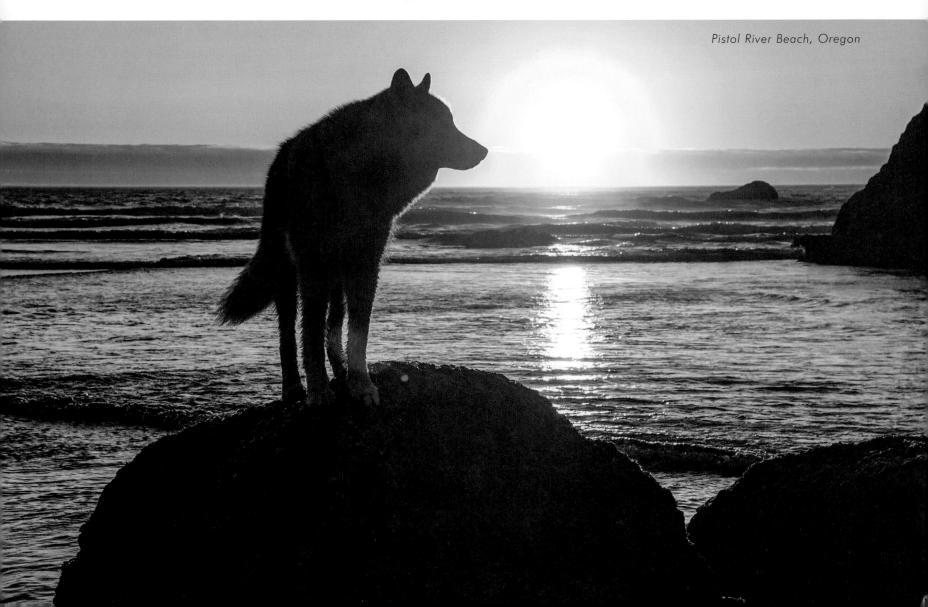

Pistol River Beach, Oregon

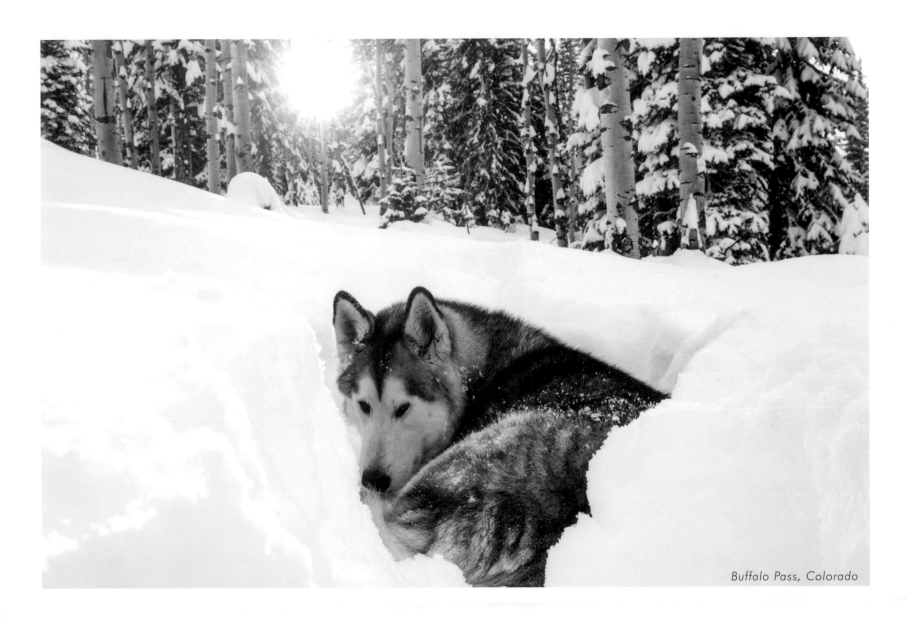

Buffalo Pass, Colorado

Whose woods these are I think I know. His house is in the village though;

He will not see me stopping here. To watch his woods fill up with snow.

—Robert Frost, "Stopping by Woods on a Snowy Evening"

Depth Over Distance

I would rather our memories root deep into my heart so I can vividly remember every detail. We could go on one thousand walks at the same park just to give him his basic needs. But I would rather take him somewhere new, somewhere that requires commitment and time.

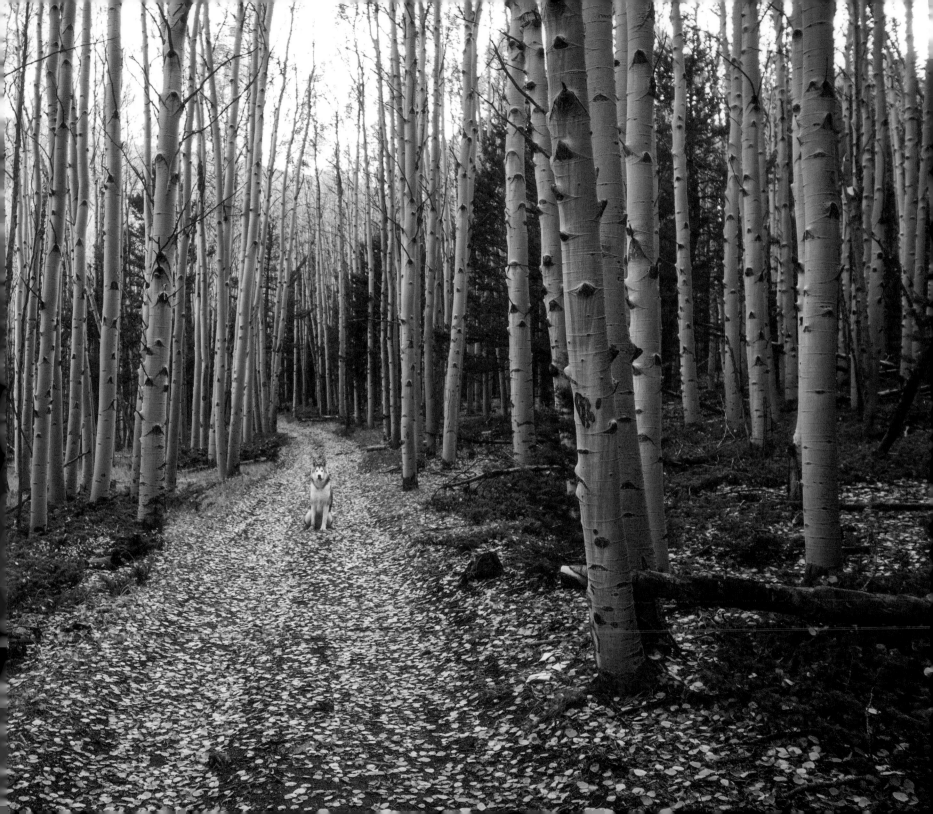

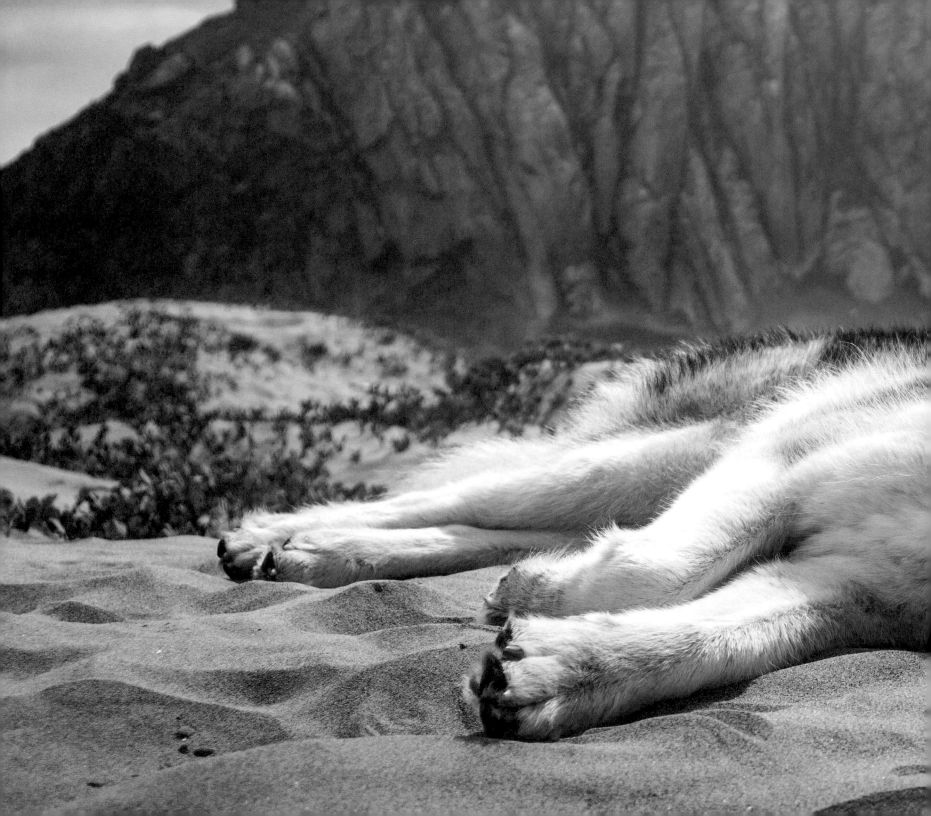

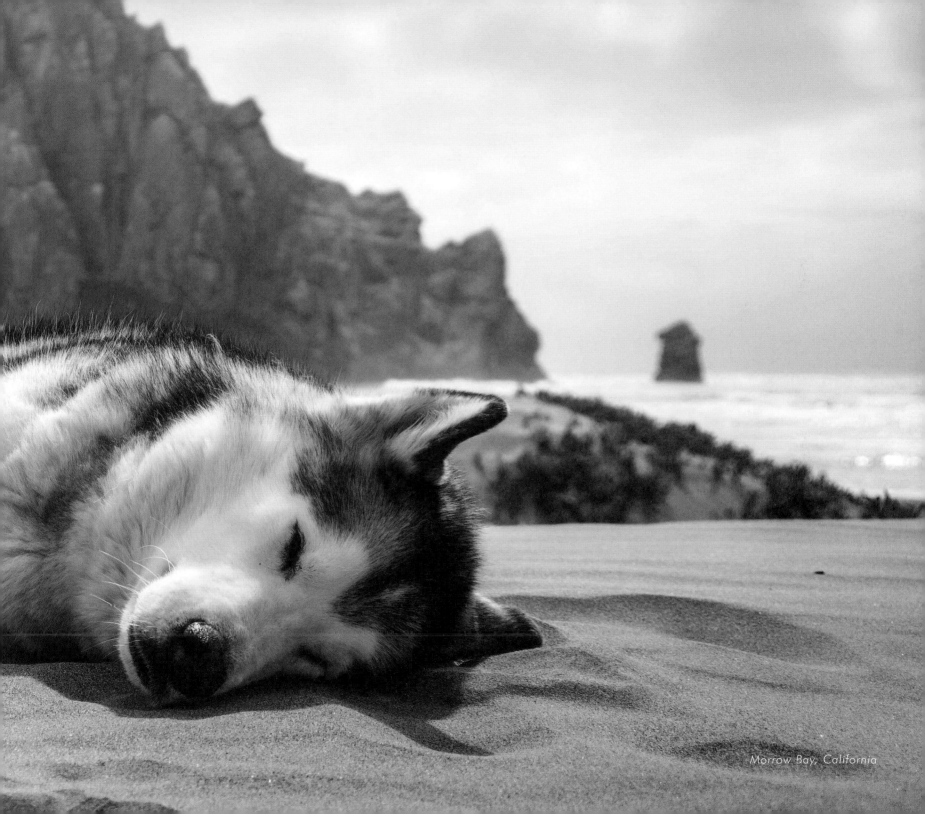

Morrow Bay, California

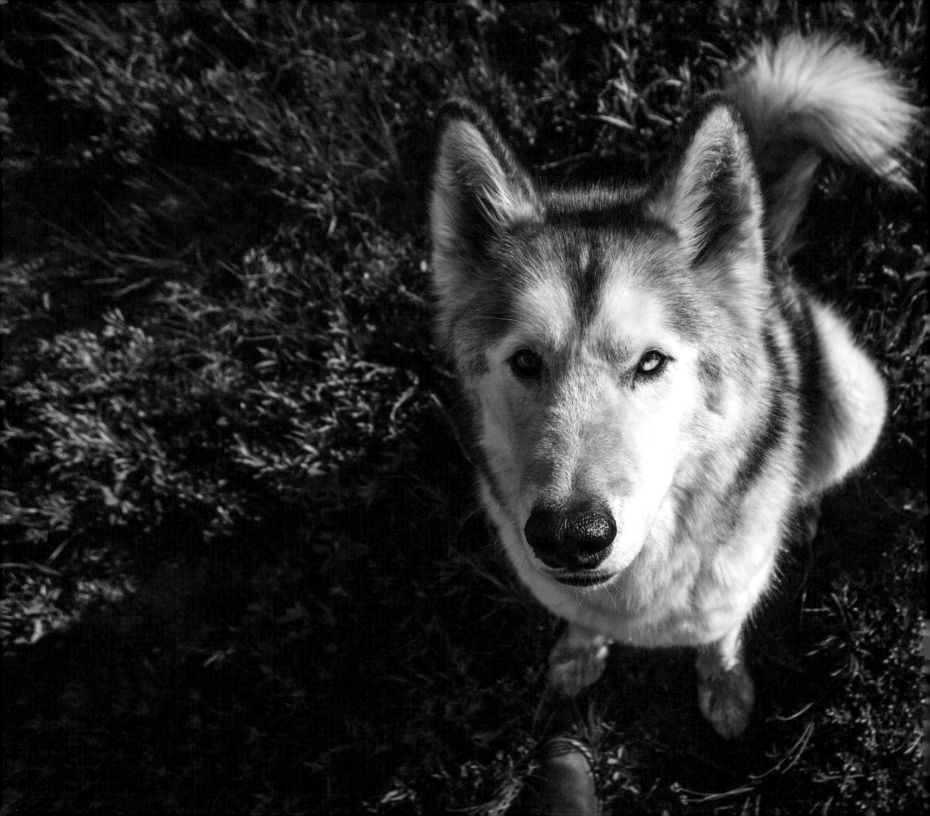

Right My Wrongs

Loki doesn't hold space for yesterday. Sure, he knows who I am, where the food is, and his favorite squirrel infested tree in the backyard. Those are the constants.

I don't think he remembers if I was happy or sad or upset yesterday. I don't think he is holding a grudge for being reprimanded for chasing a rabbit, or if he's grateful for the bones he got after dinner.

I think he just sees me. He sees his best friend who loves him and wants what is best for him. He's excited for the day even though he has no idea what it holds. The moment my alarm goes off the laundry list of to-dos starts scrolling, usually followed by anxiety. I toss around in bed trying to take a few more minutes; I know he is upstairs looking out the window. His ever-listening ears must be aware of my hesitating groans, because I hear him walking to the stairs. He comes rushing down the stairs through the bedroom door like a fur-clad torpedo.

Good morning dad. I don't care about anything else but saying hi to you. Give it a try.

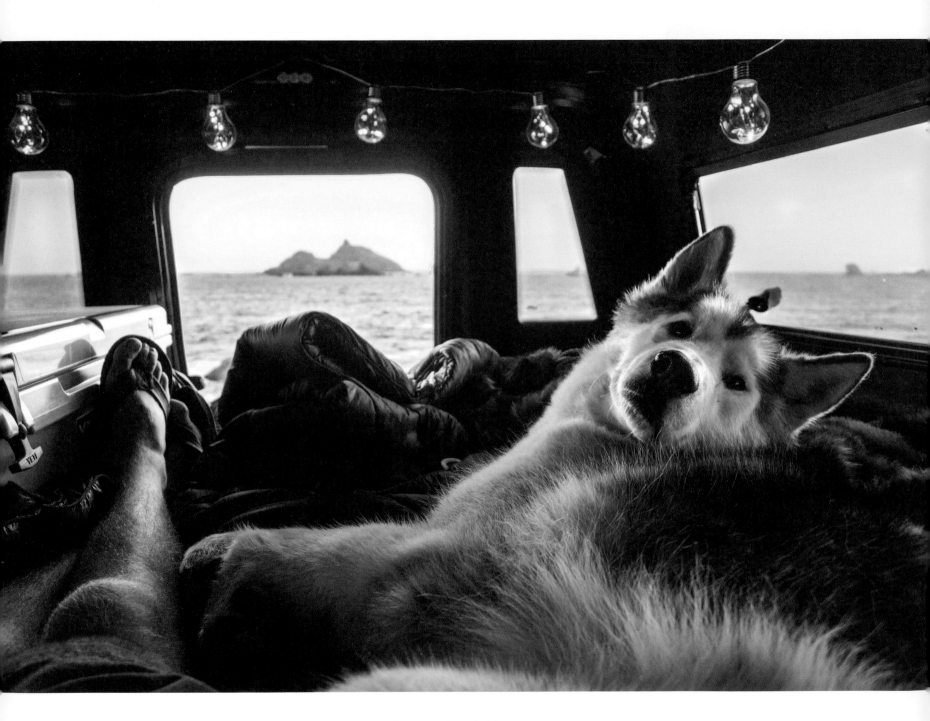

Crescent City, California

Wish You Were Here

The concept of being present is one that is so often said, but rarely lived. I'm guilty of it. I say I am going to be more present; I say I am going to put my phone down and focus on what's in front of me; I say I will put the camera down and just look with my eyes. But I don't. I get caught up and think secondary things are important in the moment, and then the moment is gone.

Never has Loki had this behavioral flaw. How could he? He sees now and now only. I am not saying that beyond my knowledge he doesn't have a memory bank of his past experiences. Simply put, he is not worried about what tomorrow will bring. The anxiety of the future, the disappointment of the past; that's not a thing for him.

If now is all we have, all that is promised, let us not be fools and waste it.

Even after all this time
the sun never says to the Earth,
"you owe me."
Look what happens
with a love like that.
It lights the whole sky.
—*The Gift: Poems by Hafiz, the Great Sufi Master,*
translated by Daniel Ladinsky

Dead Horse Point, Utah

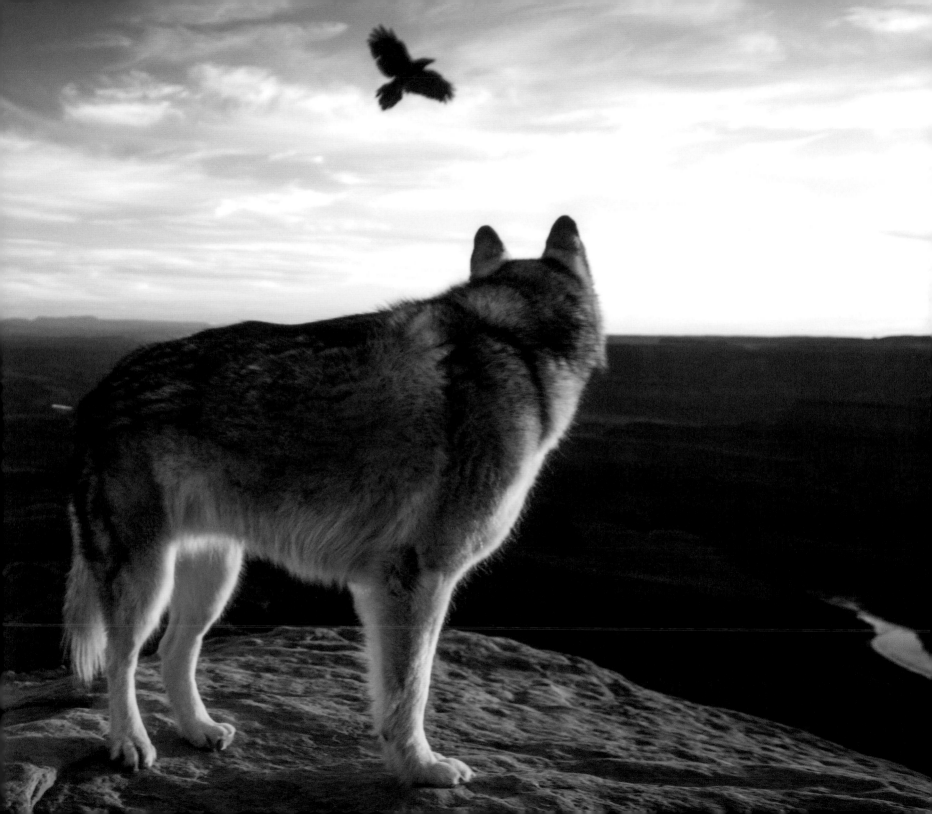

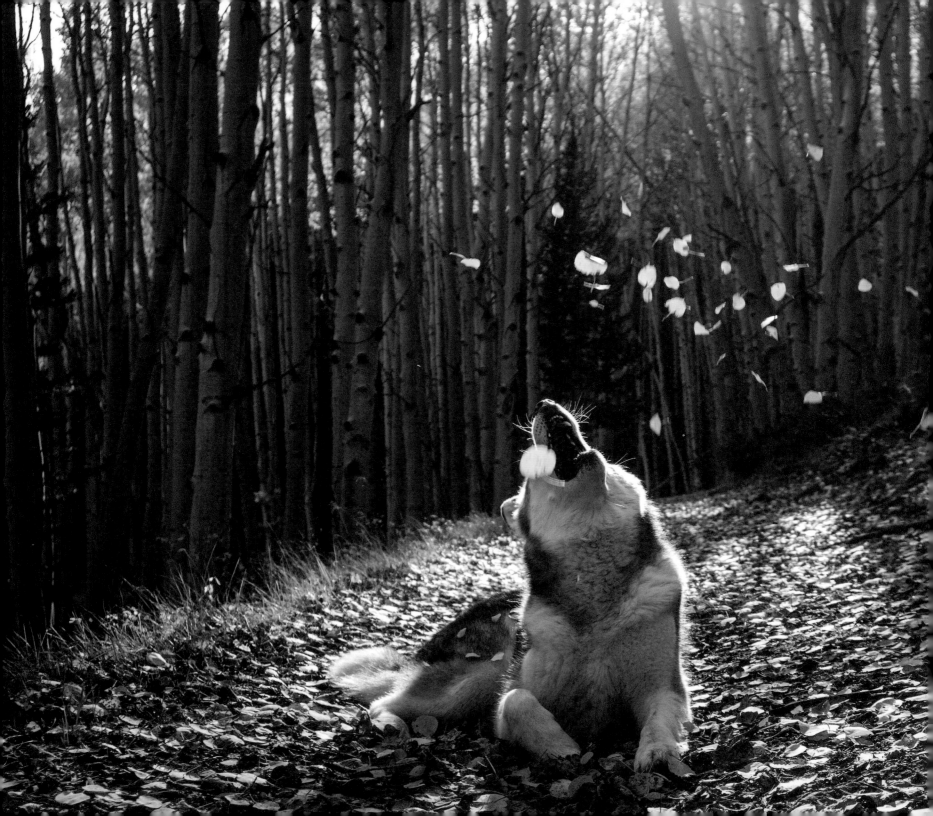

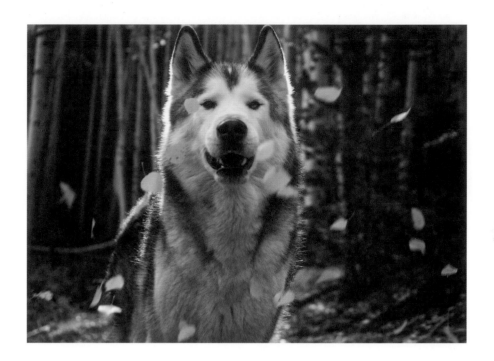

Timing

When I decided to bring Loki home for the first time, we had to drive back from Utah during a timely blizzard. An alleged sixteen-hour round-trip turned into a thirty-two-hour white-knuckled creep back to Denver; our first adventure. Life works out to the seconds, the moments we take or miss.

The wind blows and the leaves come floating down, and we are in the right spot at the right time.

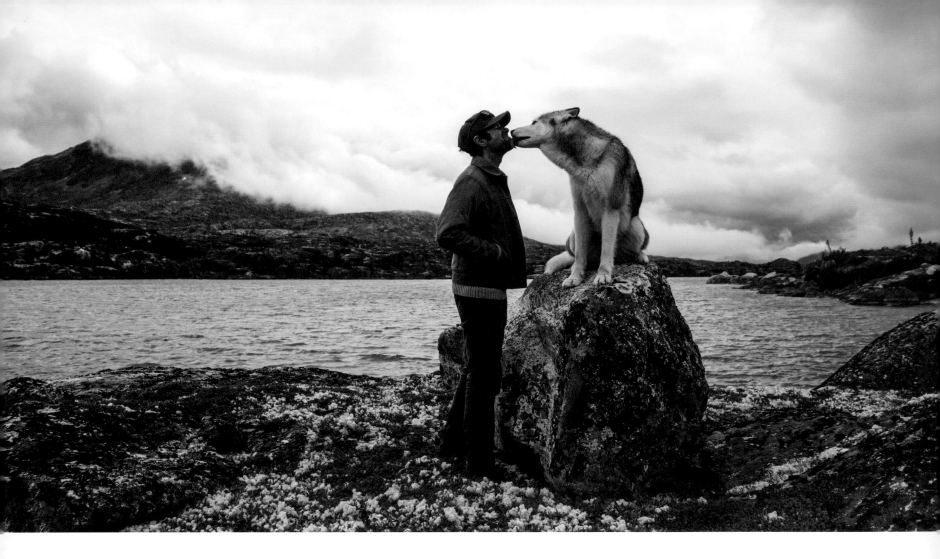

I Found You

Along the way, Loki and I have learned from one another. We were strangers that became instant life-mates. We did everything together, went everywhere together, and learned one another's souls. It is hard to think about what it was like back then, standing here now that we have been through so much together.

When was the first time I turned to him with my worries? When was the first time he found comfort in my arms? When did walls come down, and built up trust took their place? Perhaps around the time that *you* and *me* became *us* and *we*.

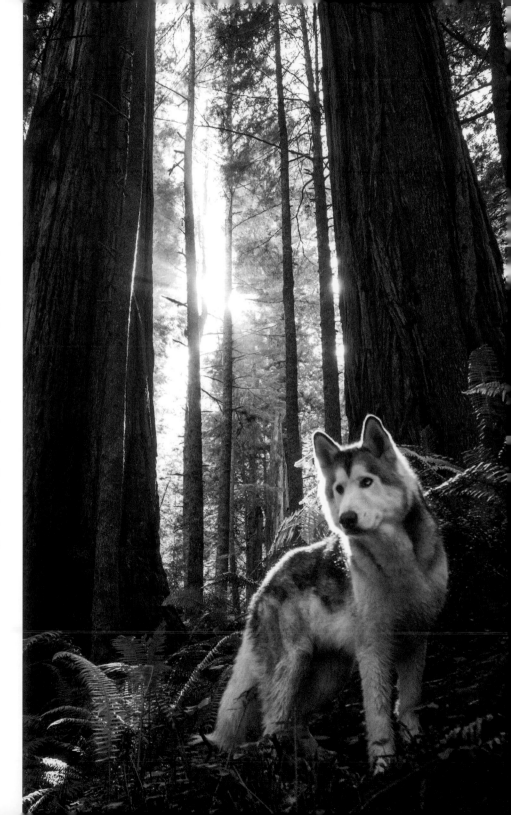

Forest For the Trees

What if memories are like trees? They grow deeper over time, their roots grow deeper into our minds. All the special moments, good or bad, get seeded, and then live there forever. The forest grows deeper and thicker over time.

What if we could take a walk through that forest? Would it look dark and rainy much like the Pacific Northwest, where the trees grow taller and taller, blocking out the light?

Anyone who knows what I am talking about knows what happens when the sun comes out. It beams through the branches and cracks, down on to the forest floor, giving more life. Those golden moments make more trees. This is one of them.

Howland Hill Road, California

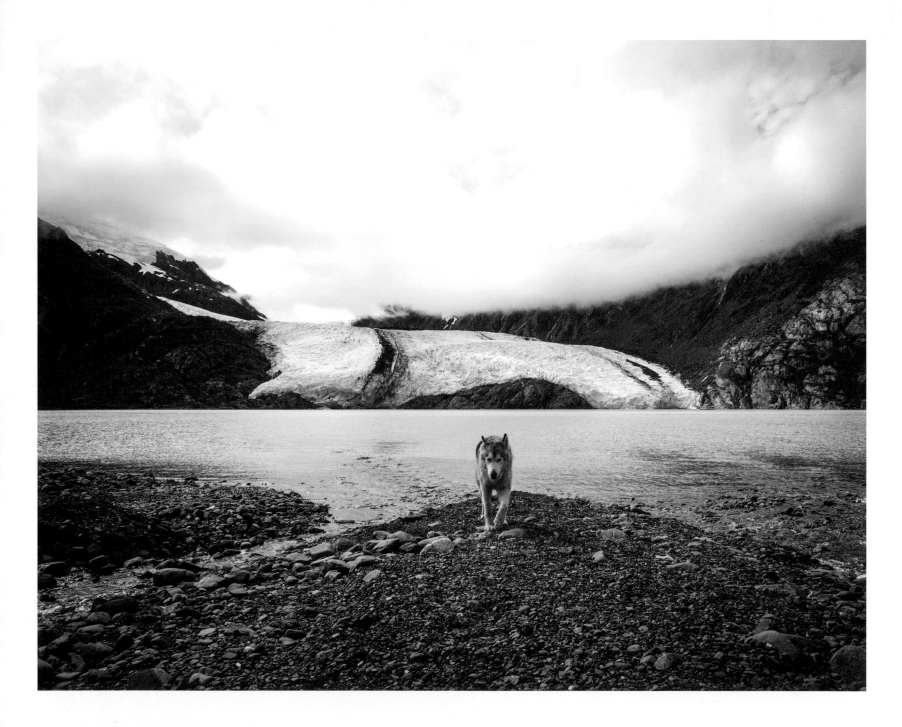

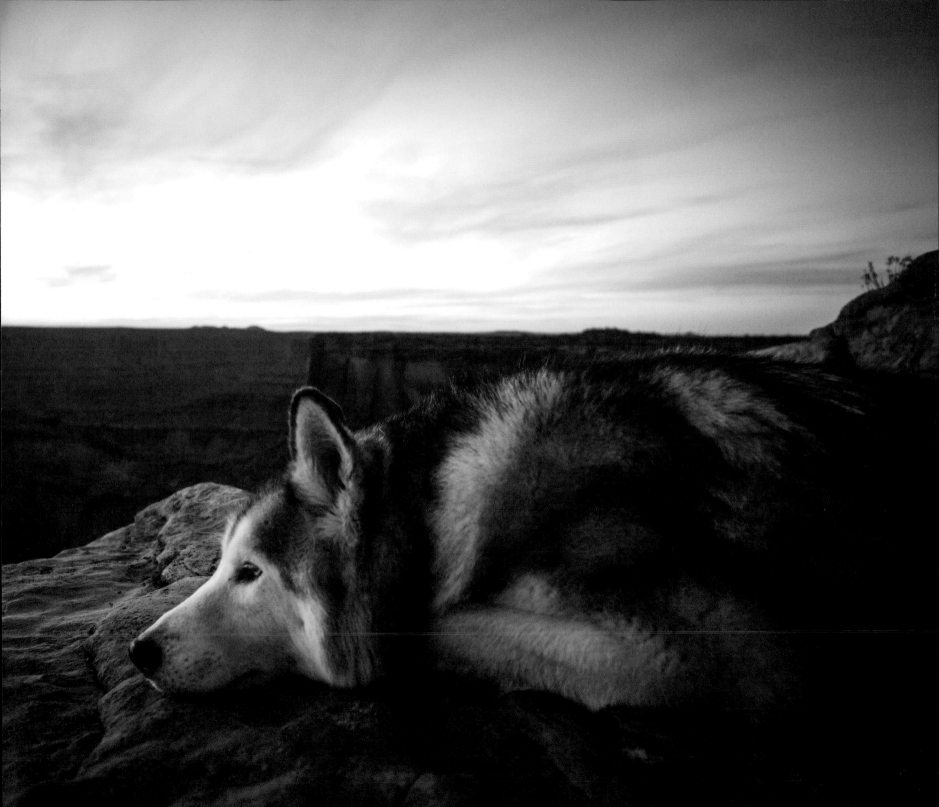

Baby, it's cold outside.

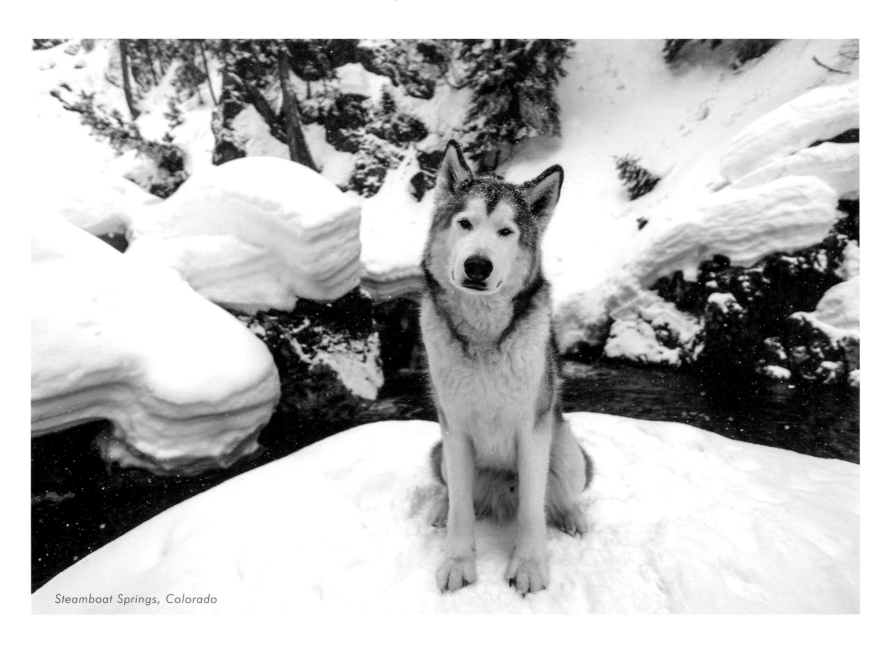

Steamboat Springs, Colorado

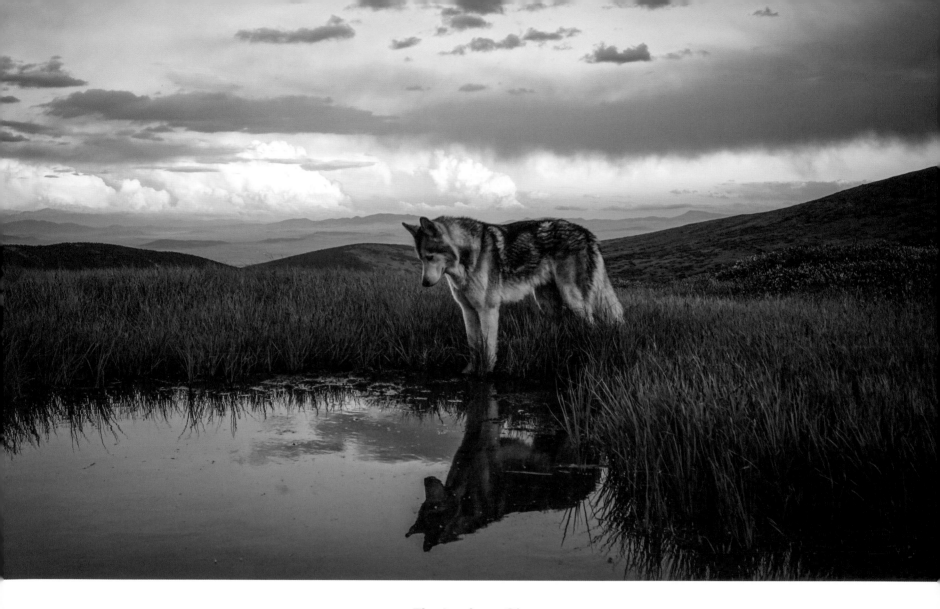

The Looking Glass

There is honesty in a relationship with your dog that may not be achievable in most human relationships. It is often said that a dog will match his owner, in some form or another. Maybe they share similar body configuration or maybe their disposition is the same. When this is all said and done, I will consider myself lucky if I get to be a reflection of Loki.

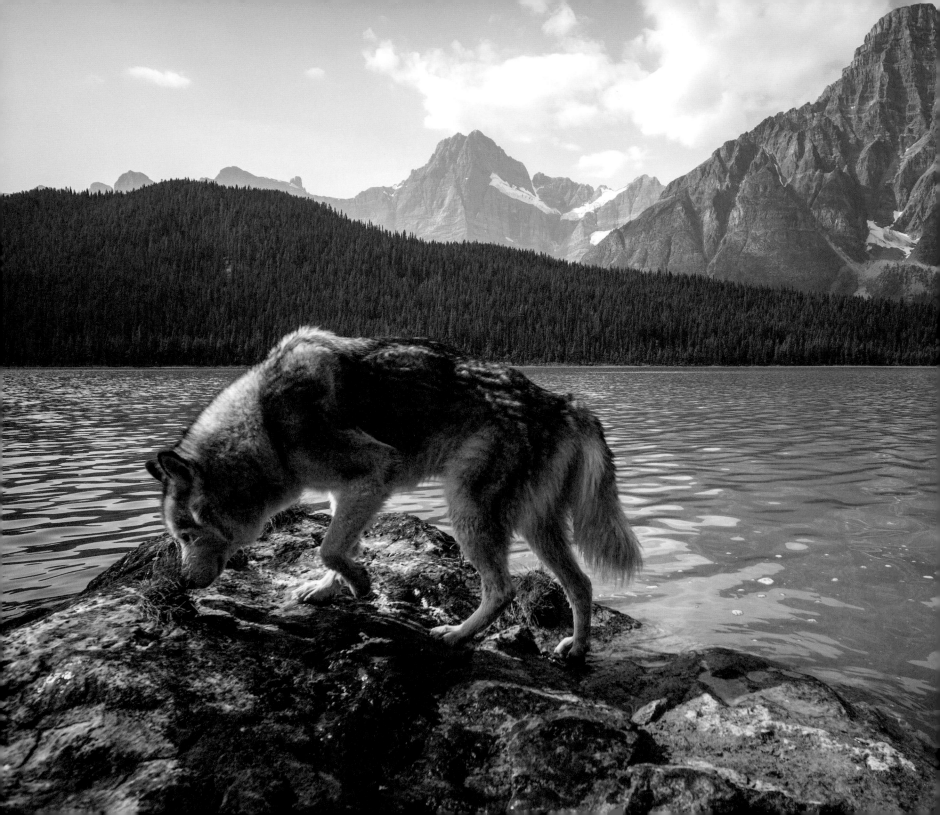

Be Free

If I had Loki cooped up all day alone and bored, he might have been a different dog. He could become destructive, unruly, and overly hyper. I never wanted that for him.

I feel an obligation to keep him safe, but even more so to help build the confidence in him to be obedient off leash so that we can freely explore the outdoor world.

Alberta, Canada

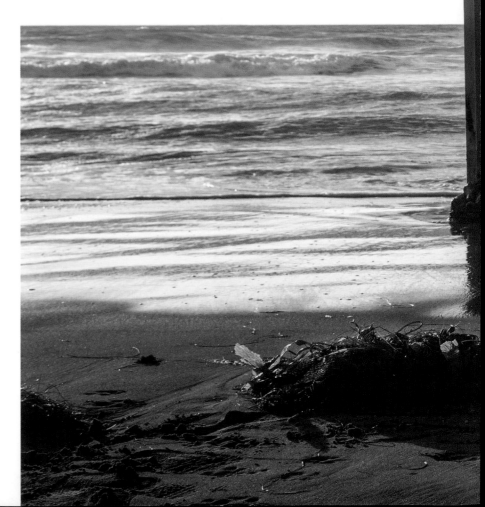

Man's Best Friend

Everyone thinks that his or her dog is the best dog. And everyone is right. Dogs have an innate nature that is pure and genuine; it can't be argued with.

Ocean Beach, California

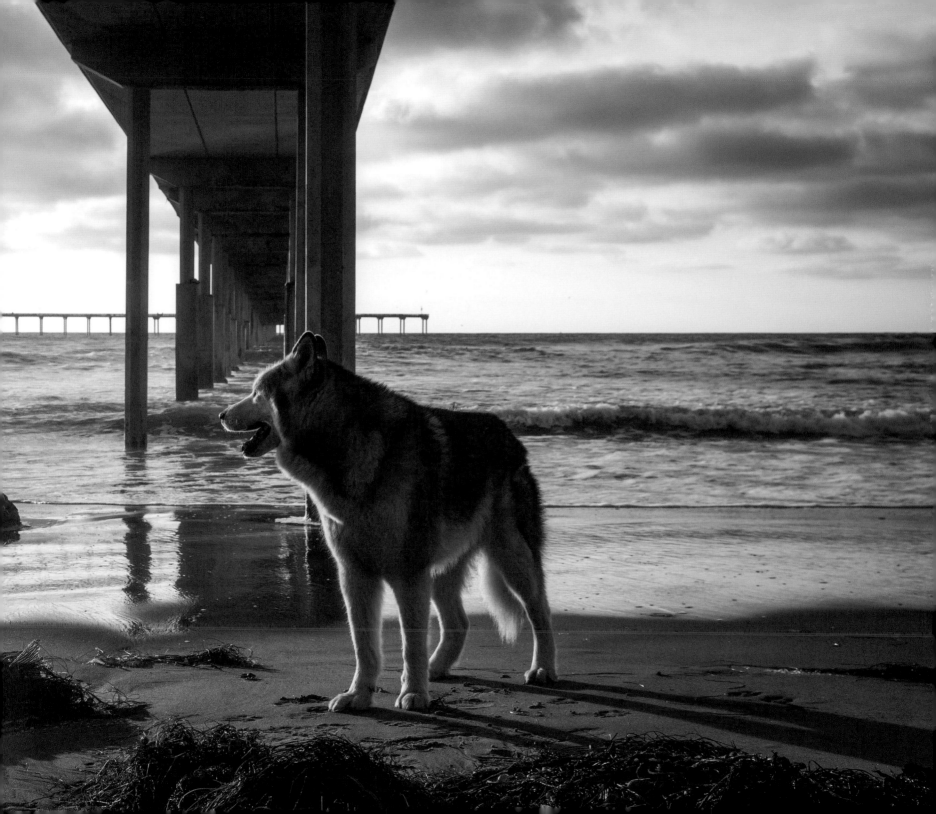

Keeper

It is in these final moments of the day, that I find myself most connected to Loki. It is not because we are alone and the day has silenced. Rather because he is asleep at the edge of my bed knowing I am here, even before I rub his face. He knows this is our home and that we are each other's keepers. He knows he is safe here, and I feel similar knowing he is close. I can hear him breathe in and out; I can see his paws relax on the sheets and, finally, the shift in breathing when he truly falls asleep.

There are no words elaborate enough to describe how I feel toward him in these moments; I can only say that it is here that I learned that communication is not only about the words we share, it is about something else entirely, something intangible. How can two different species that share no shred of commonality understand one another? How is that bridge gapped so effortlessly and instantaneously? I believe the answer to be, *love*. It is only love that transcends all logic or science. It is only love that can explain this moment. It is as if we chose each other far before this life.

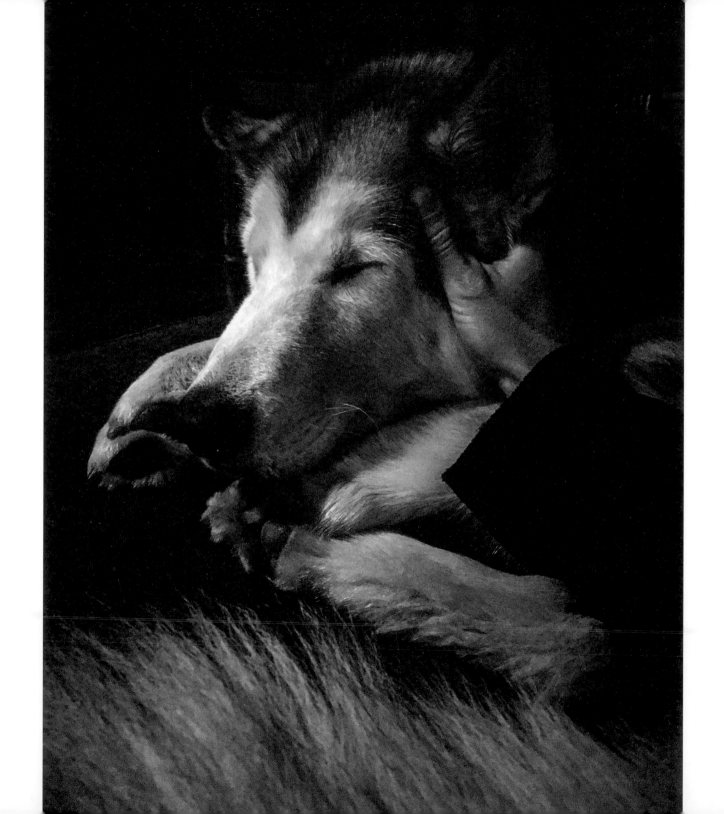

Hold my calls.

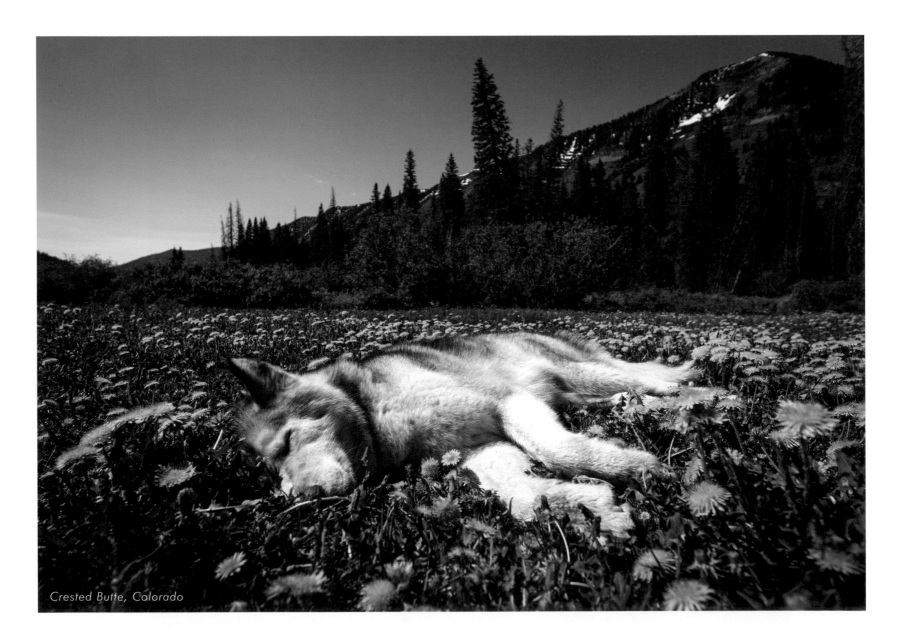

Crested Butte, Colorado

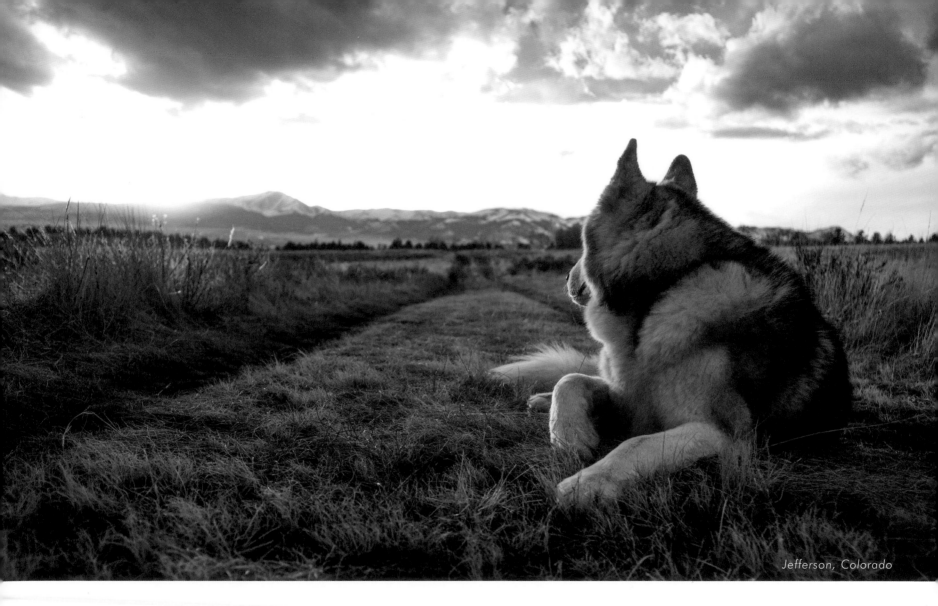

Jefferson, Colorado

Wildlife Encounters

Since we drive everywhere we go, we see so much of the countryside. Loki sees livestock, deer, elk, moose, and I've even seen him try to say hello to a coyote in a field.

I feel that Loki was most fascinated by his bear encounters; I suspect it is because he wants hibernation tips.

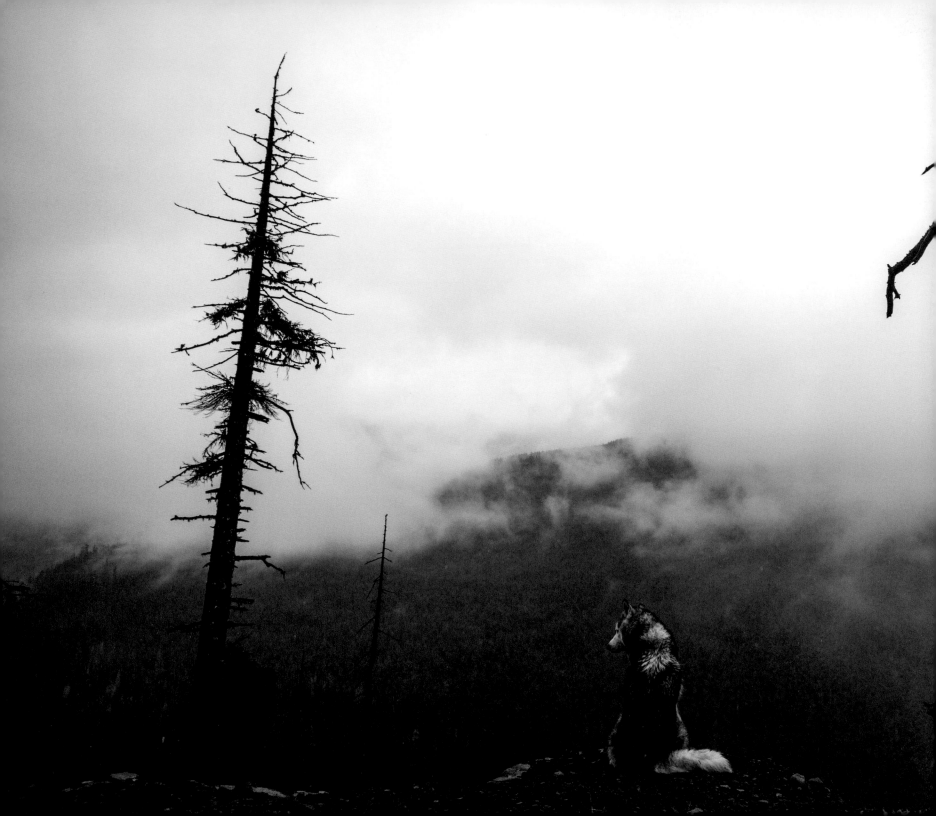

It Had Better Be You

Death is not a popular conversation. It is a cruel fact of life that dogs cannot live forever. If I am being honest, the thought creeps into my head from time to time. One day Loki will not be here with me. I will only have these photographs and quite a bit of his hair on my clothes. Selfishly, I cannot fathom how I will face reality after that point.

I do view him as my child. Contrary to typical human life, my child will pass undoubtedly before I do. I don't want to let him go. I don't want to walk in the woods knowing he doesn't follow. I don't want to hear the silence in my house knowing he's not coming to wake me up.

Dog years are inevitable. We are almost the same age at this point. He's wise, mature, and knows so much of this world already. He will only ever know life with me, but I will have to go on living in a world without him. It's like watching a movie in fast forward, we already know the ending, and the hero dies.

No. It had better be you. It just has to be you that outlives me.

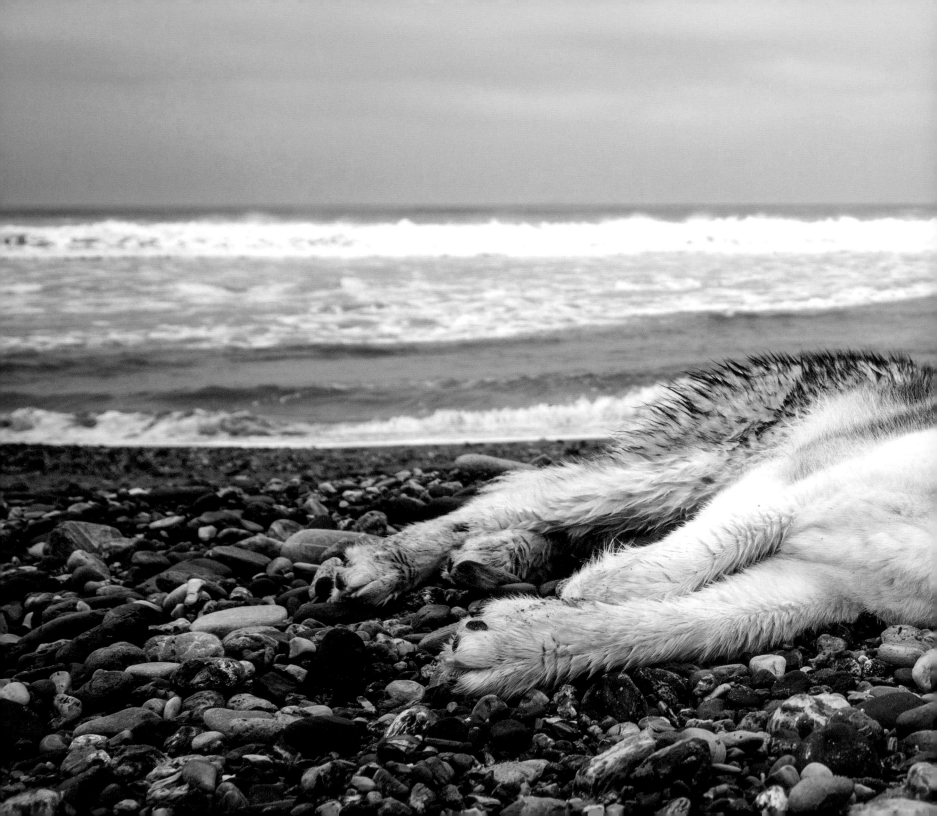

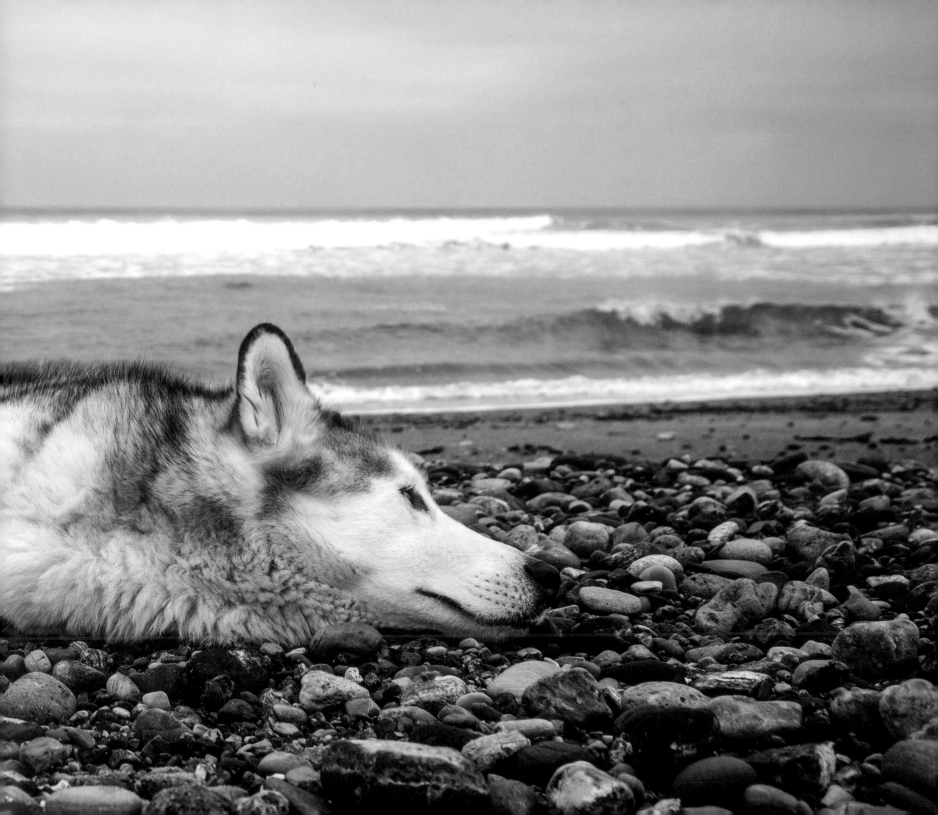

This is what it's like to love you.

Pittsburg, Colorado

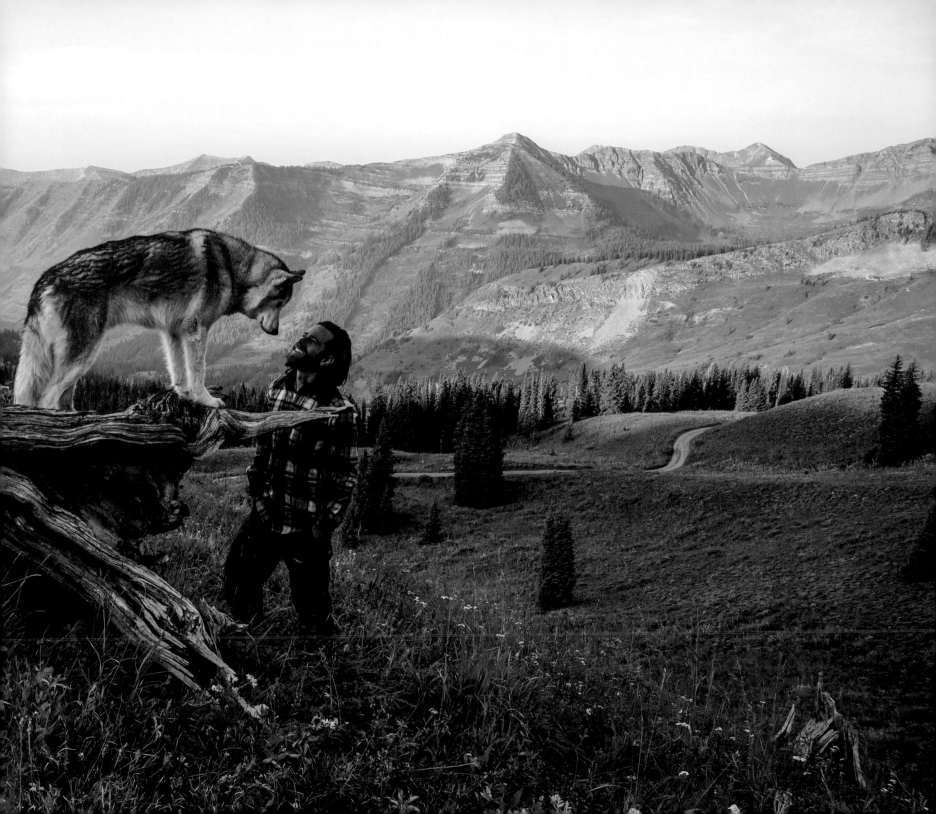

How to sleep until noon.

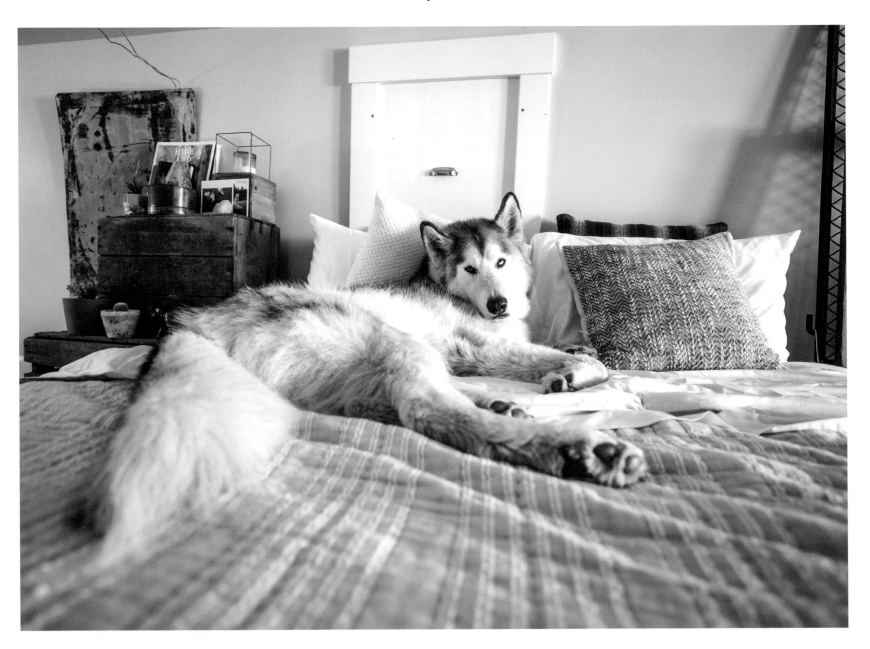

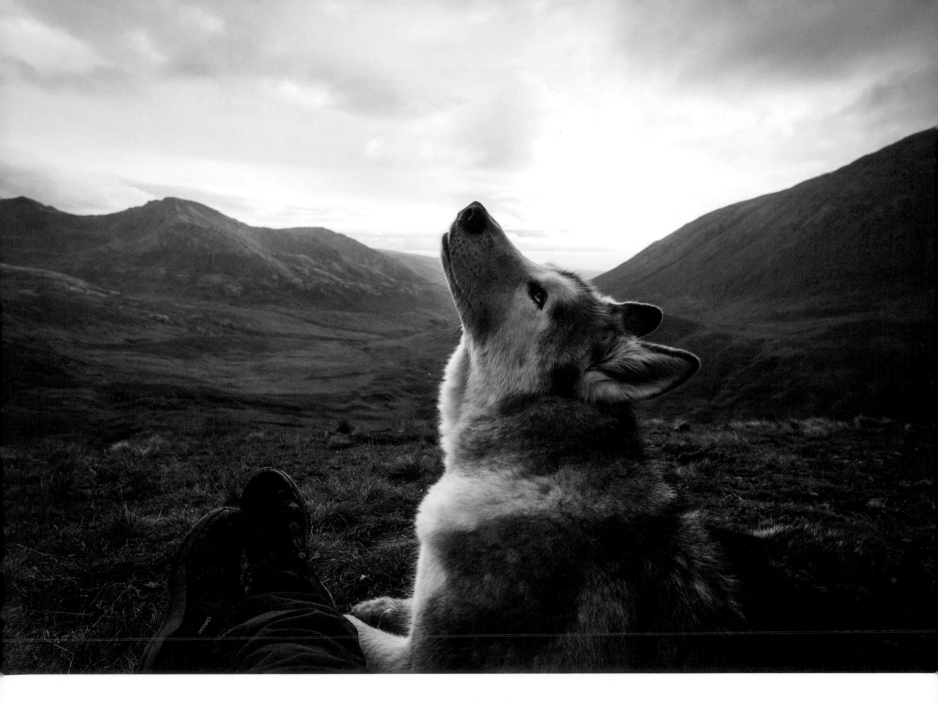

Kiss the sky.

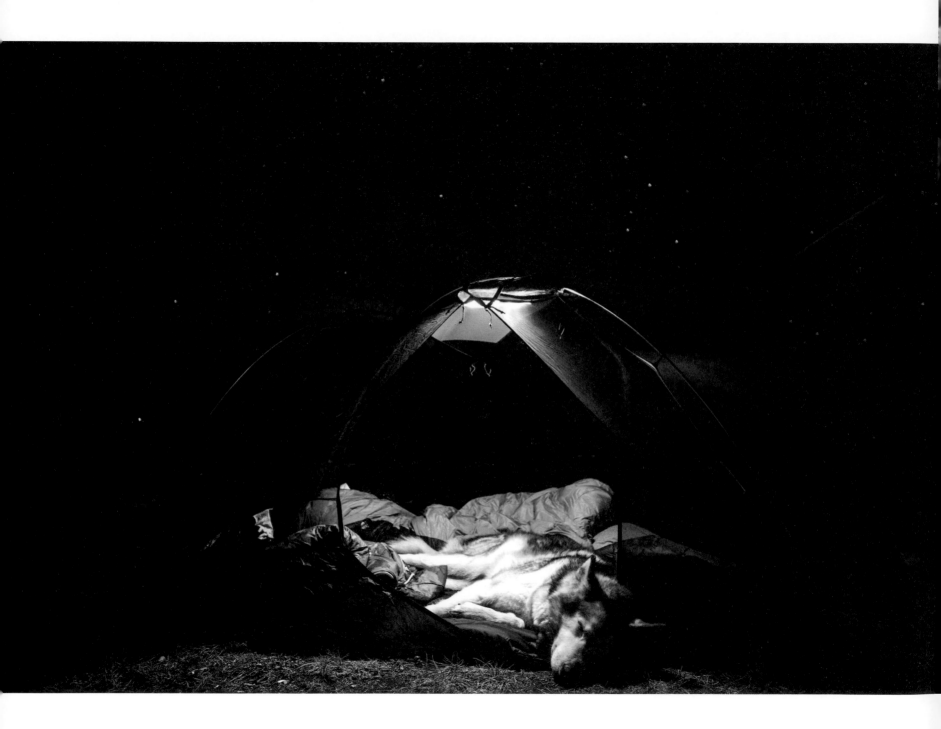

To the Moon & Back

Travelling has become more comfortable than waking up in the same bed every day. The revolving door of a packed and unpacked bag, rinse and repeat, is just how life has been for some time now. When we leave the house it feels less like leaving home and more like we are searching for home *tonight.* I feel like our need to see what's around the next turn drives us into the late nights, and forces us out of the warmth of a sleeping bag in the early hours.

Loki gets to feel different parts of the earth under his paws. He knows what the desert sunset looks like. He knows what the icy wind raging over the mountains feels like. And much to my aversion, he knows what the Pacific Ocean tastes like.

I think it is a promise I've made to him, and maybe to myself. *From as many places as I can, I promise to show you what the moon looks like.*

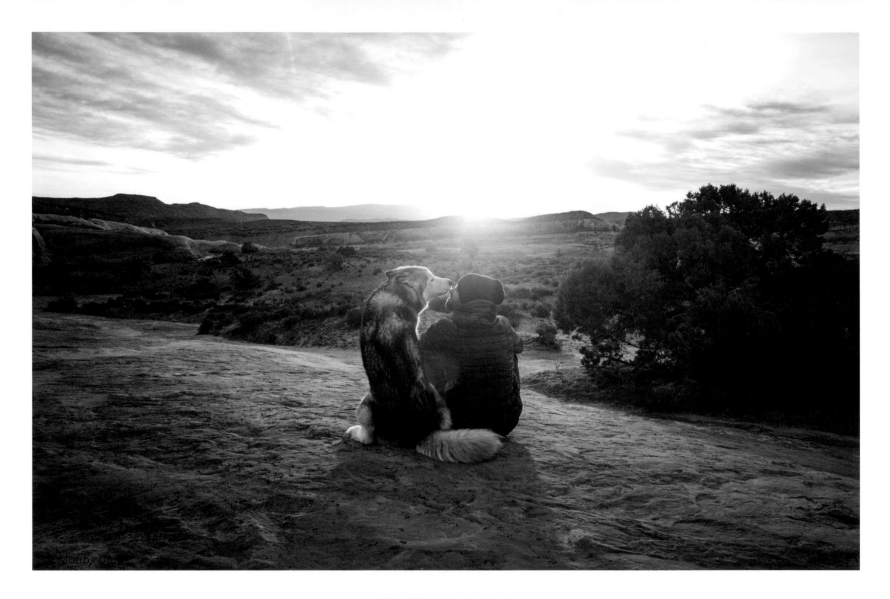

The Night We Met

How long is long enough to love? I loved him the moment I had him.

 We didn't know each other or how life would be, but I knew this feeling was undeniably love. It's woven inside me as deep as the muscle tissue and blood flowing around my heart. That will never fade.

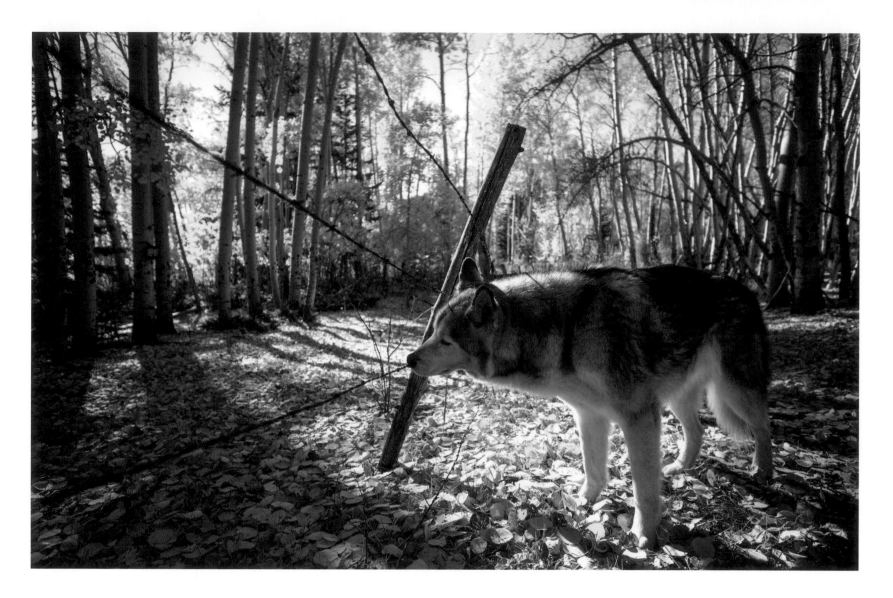

Risk is Reward

There's a risk in exploring. It is a weight that we bear in finding something that has been left unfound.

Every time we set out somewhere new, I feel the heaviness; it isn't necessarily a bad feeling either. It's a polite pressure to find the unknown. And once it is found, that's the feeling of release. It's the magic we all search for.

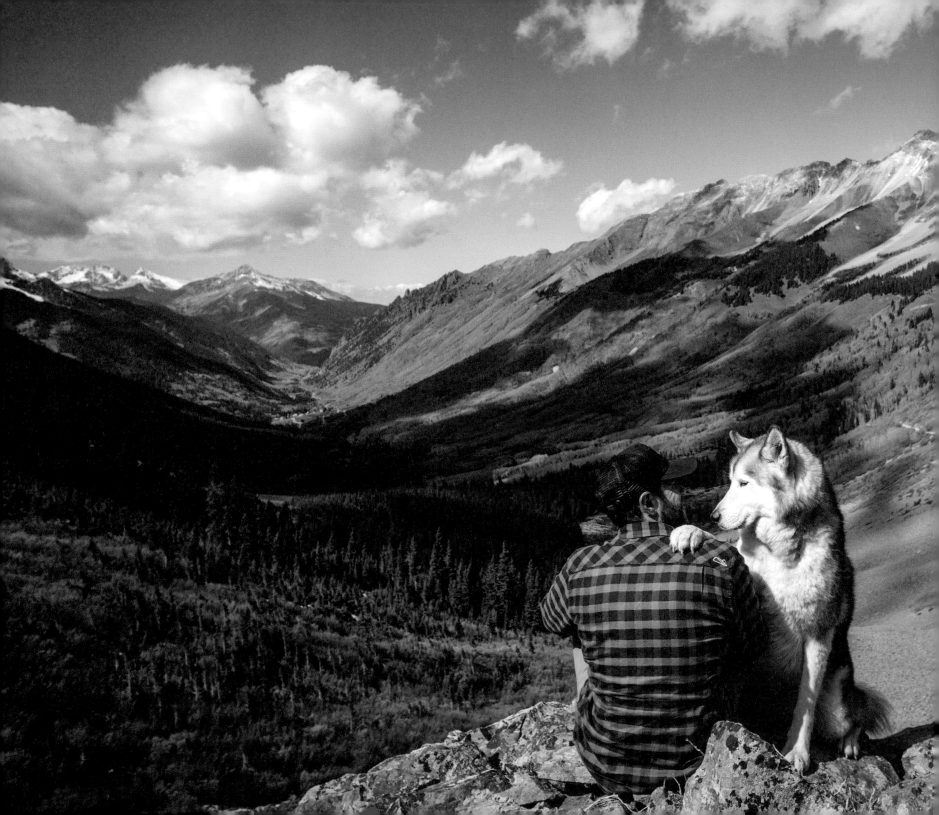

BOND

It is that feeling in your heart when you feel it about to come out of your chest. Suddenly everything feels whole, even if it's not. You have your best friend next to you and the world seems to fluxgate into something full of possibility that wasn't there before. It's as if together we can achieve this unattainable challenge, but only together.

You Shall Not Pass . . . without treats.

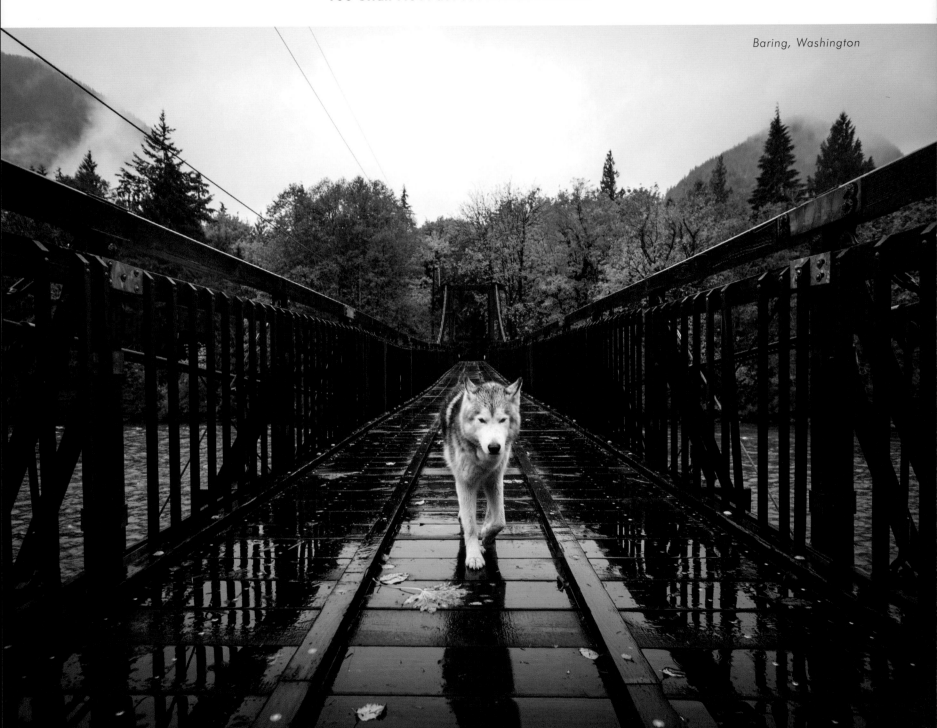

Baring, Washington

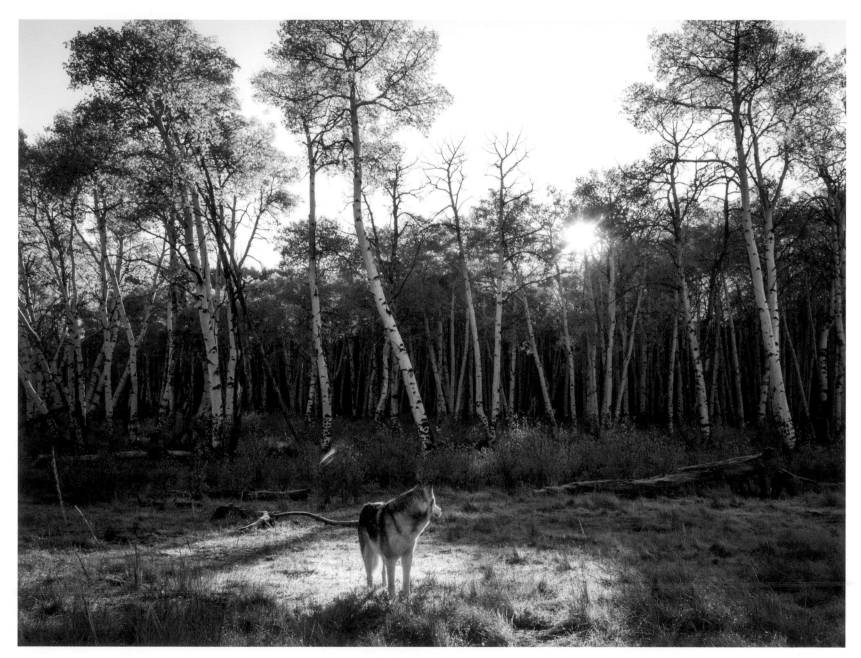

Rio Grande National Forest, Colorado

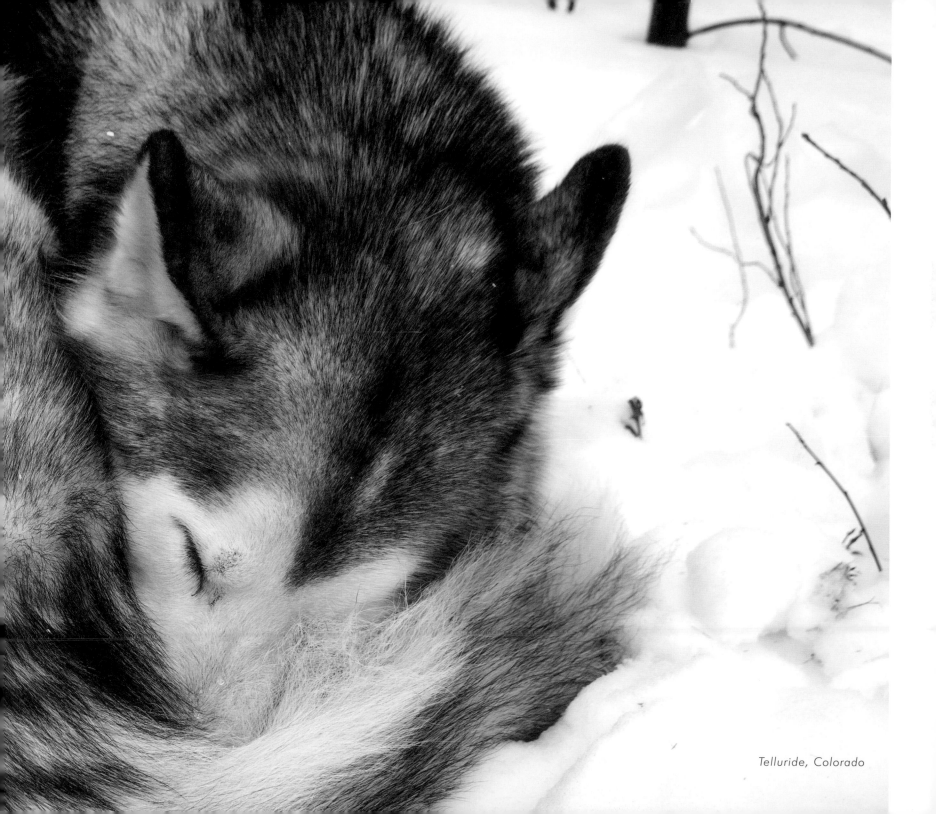

Telluride, Colorado

The Better Outdoors

Loki's desire for the outdoors is unlike anything I have ever seen. When we pack up into the truck and start driving, I know he is assessing my movements and the changing scenery at seventy-five miles an hour.

There is the place where he buys my food. We passed it.

There is the place where I saw that cat one time. We passed it.

There is the place where we go when dad is tight on time but wants me to run. We passed it.

We are driving faster now. The trees are surrounding us.
I know he's taking me somewhere better.

Mystery Lake, British Columbia

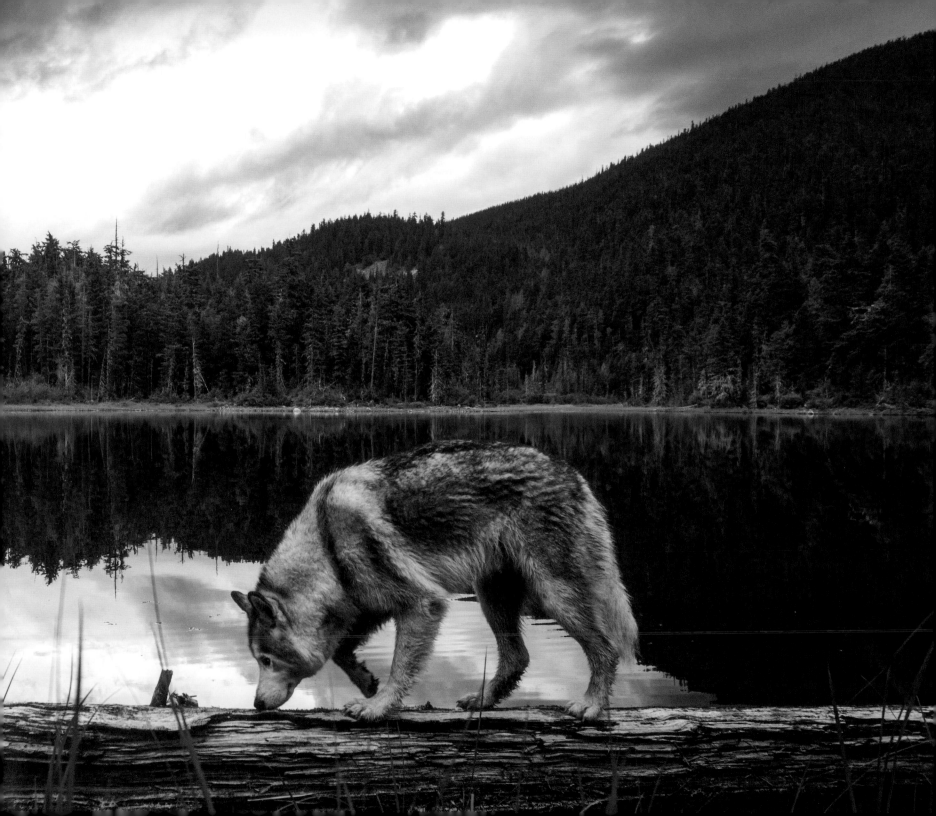

A Nine To Five

Everyday life with Loki was a lesson to be learned. I didn't know much about dogs like him, and I couldn't anticipate how he would change my life. His needs suddenly became my priority and I began restructuring my own agenda to provide the best routine for him.

All dogs have their idiosyncrasies. Loki doesn't like strangers approaching him quickly; he puts his ears down and turns his back to hide his face. He has a tendency to want to escape if he is not comfortable in a new place. He's not too keen on gunshots. The jury is still out on how he feels about cats. So the obvious conclusion is to avoid those situations; lock up the house so he can't escape, comfort him with strangers, avoid going near firing guns, and not setting up a play date with the neighbor's cat, Mr. Meow.

The commonly untold rest of the story is a tale of far more change than these small tweaks. Loki is a large animal; his body craves movement and use. A simple fifteen-minute stroll around the neighborhood won't suffice, and I know the looks he would throw my way, *That's it? Really?* It would be unfair to keep him under lock; if I want to share my life with an animal like this, I owe it to him at the very least to provide a life where his physical and mental health needs can be met.

Another chapter to the story is meeting those challenges head on and trying to help Loki mature. We are in the woods, and a hunter fires off in the distance. I see the immediate change in Loki; he wants to flee to a place where I cannot keep up with him. This endangers his safety, and if they keep firing, he may keep running. I keep calm and don't acknowledge the noise, showing him that our behavior does not need to change. I talk to him with no inflection in my voice, *you're good bud, stay here*. I calmly pet him and offer him comfort in the truck or on a leash with me. Over time we have broken down the fear.

Very quickly, this mindset led to my life transforming. It was not just about me anymore, he get's a vote, too. I typically won't go places without him, work included, and my schedule only works if his comes first. I think most dog owners will agree, sometimes we as humans need that walk or run just as much as the dogs do, maybe more. Let's call it one of the many overlooked gifts they give us.

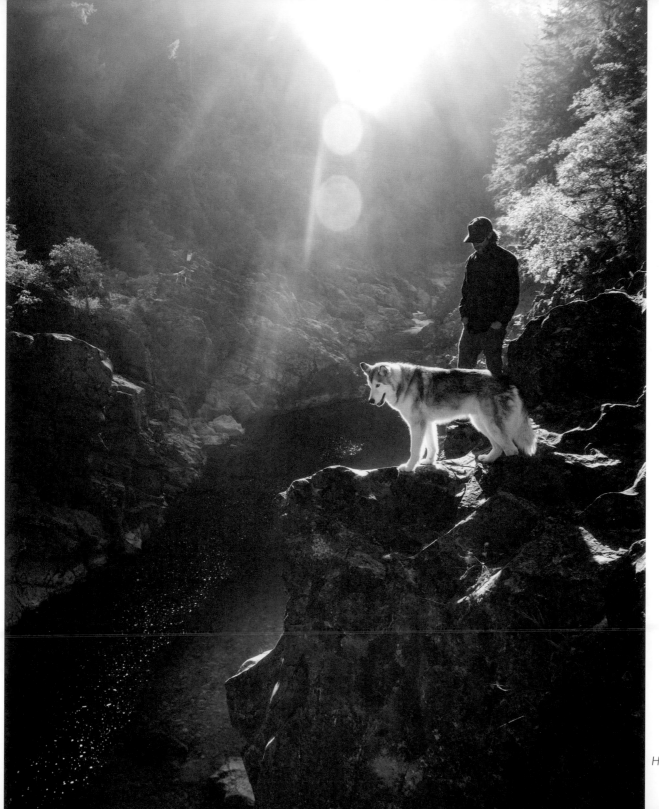

Hiouchi, California

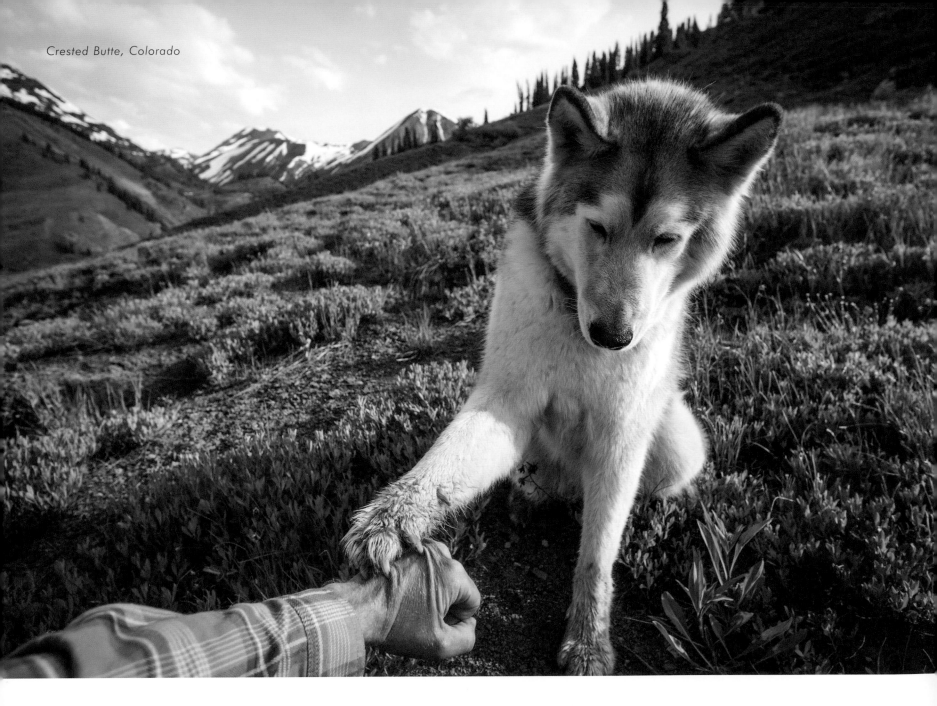

Crested Butte, Colorado

Fist bump at your own risk.

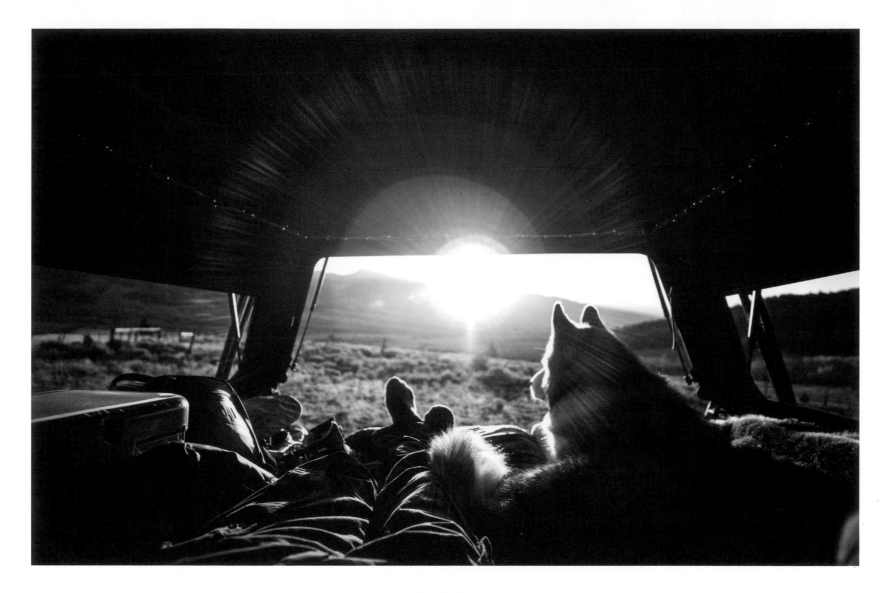

Co-Pilot

We drive everywhere so Loki and I can be together. He knows backseats well and that my headrest is actually his perfect chin rest. He opens the window when he wants and throws his head on the center console when he's dramatic about how long we've been in the car. We share the same taste in snacks and music, one of those I've been able to prove.

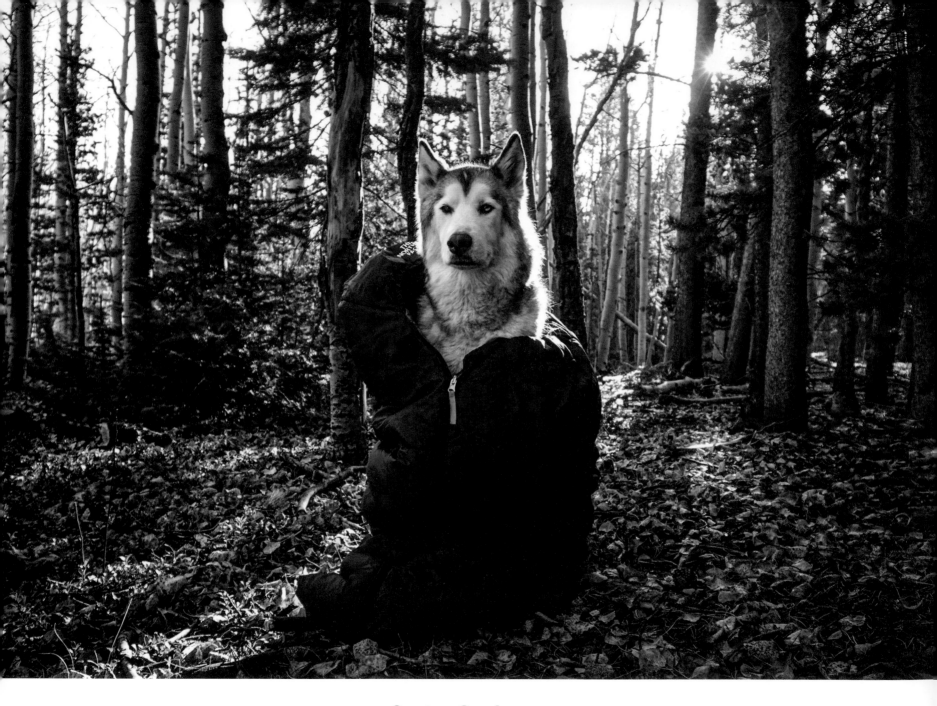

Creature Comforts

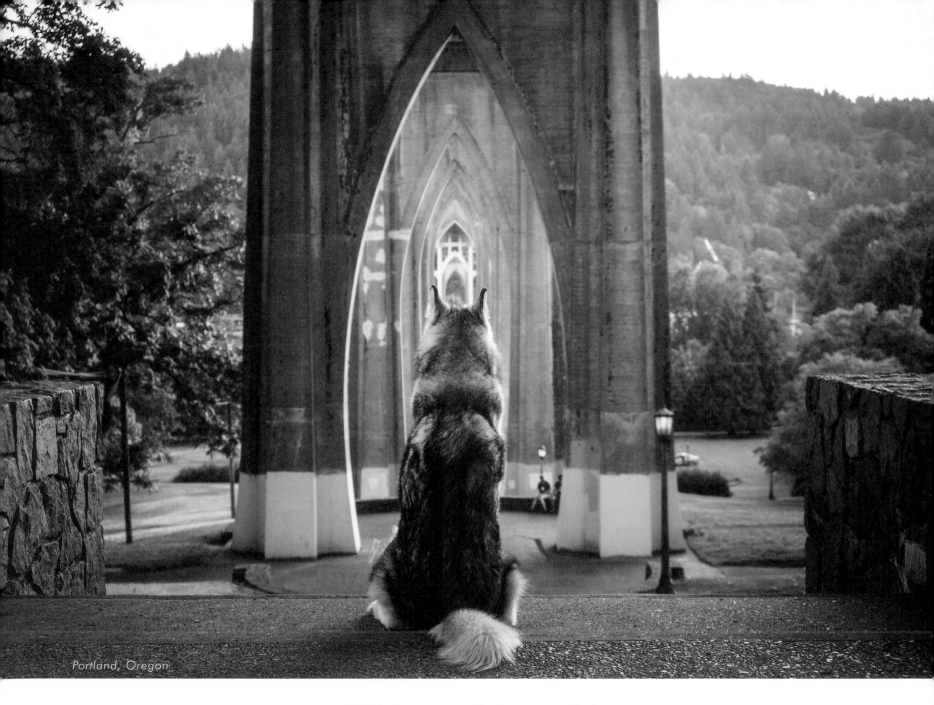

Portland, Oregon

Wild places are not always wooded.

Old Growth

We drove thousands of miles this trip. Alongside the road were logging operations, too many to count. Seeing the harvest of trees is always incredible and humbling. It feels like the end of a great book, sad to be over but hopeful for the next great beginning.

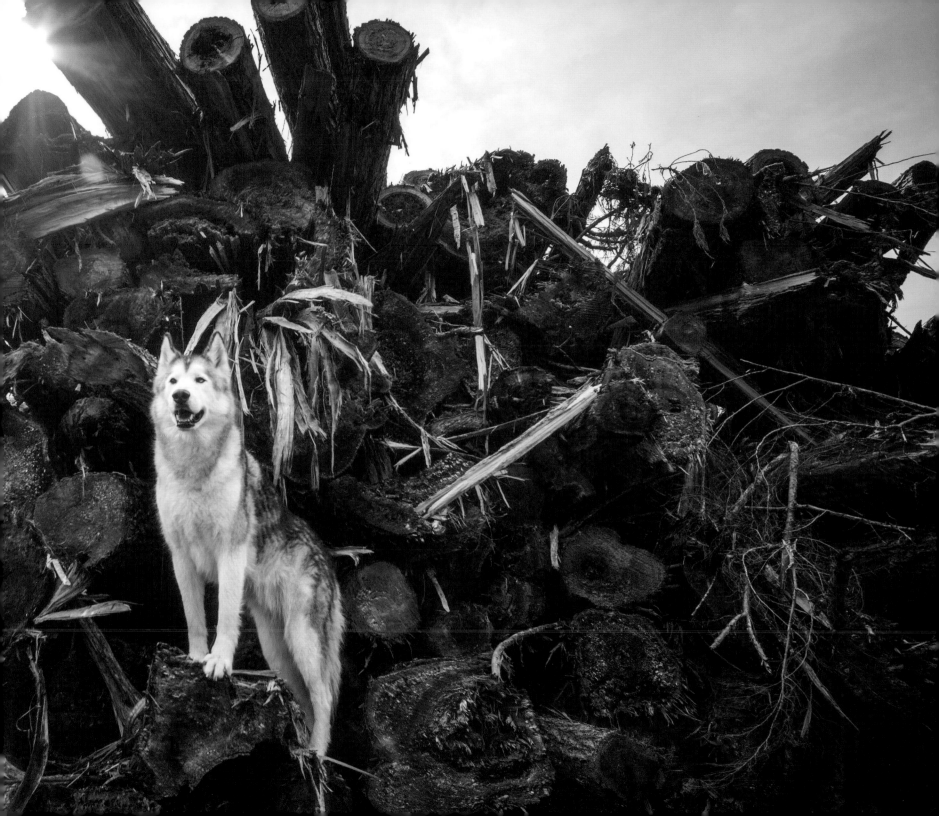

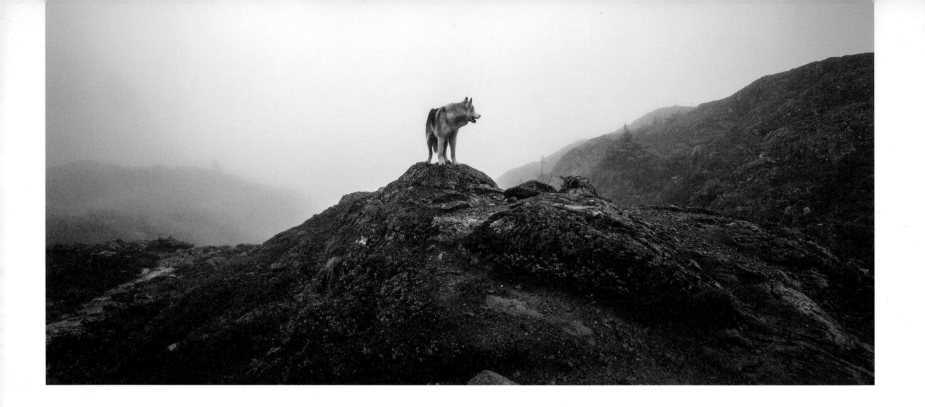

You Won't Go Lonely

It is that feeling you have at unexpected times. The sharp jab in your chest space; you can be surrounded by people on a train, alone in your house, or walking on a trail in the middle of nowhere. This feeling has no respect for time or space and shows no bias. It does not stop when you tell it to go away, and often times comes on stronger the more you turn your back to it. We call it loneliness.

I didn't get Loki to ease this feeling. I would go as far as to say that this feeling hits me just as often with him than when I didn't have him in my life. It has become more complex with him. I don't even think it is a shared emotion most of the time.

Do I need him? No. But I do feel that I need him. I don't know where the line gets crossed or how to explain certain emotions I have toward him. I know I never have to go anywhere, technically, alone. As long as he lives, there is a beating heart inside of a body that pumps full of blood with nerves and alike emotions walking next to me. I can't really see us as separate entities at this point.

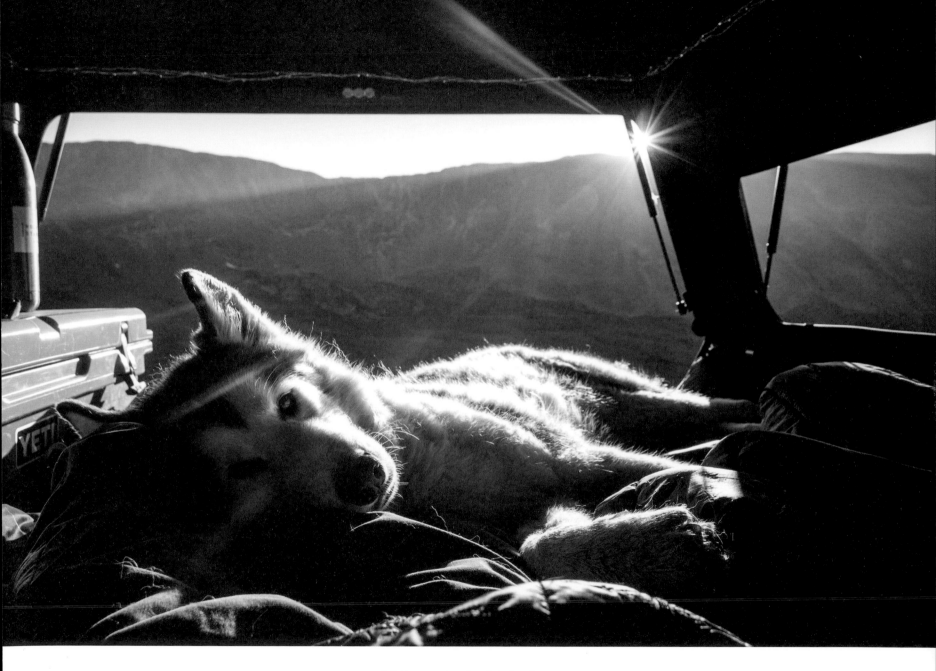

Hide me in the high places.

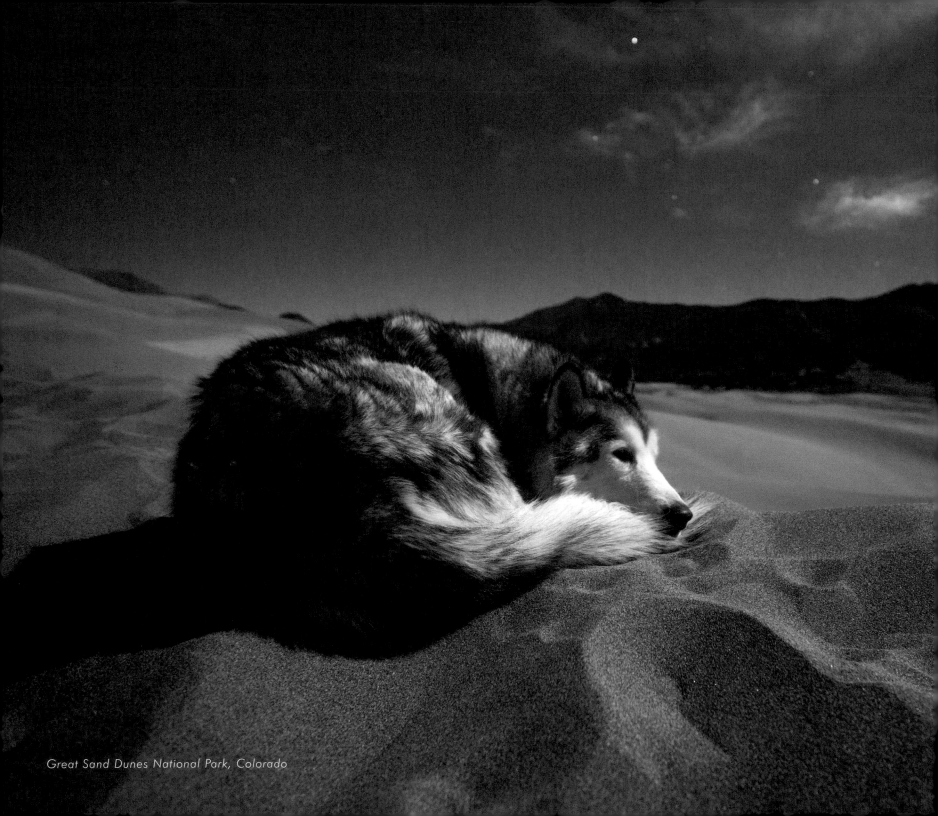

Great Sand Dunes National Park, Colorado

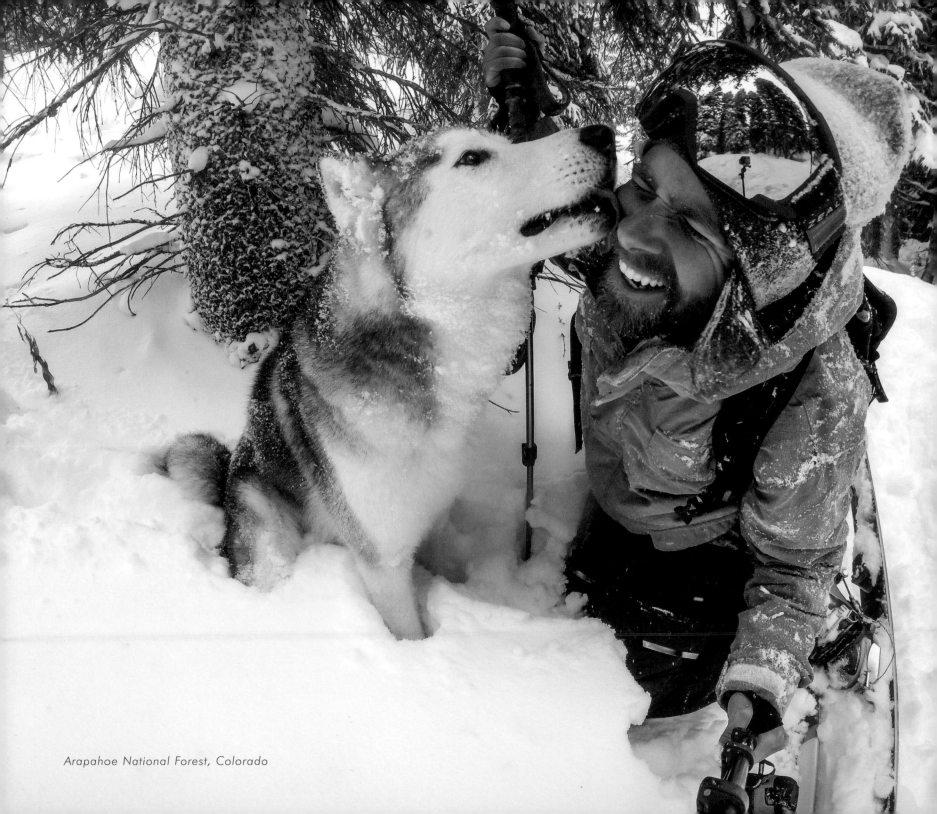

Arapahoe National Forest, Colorado

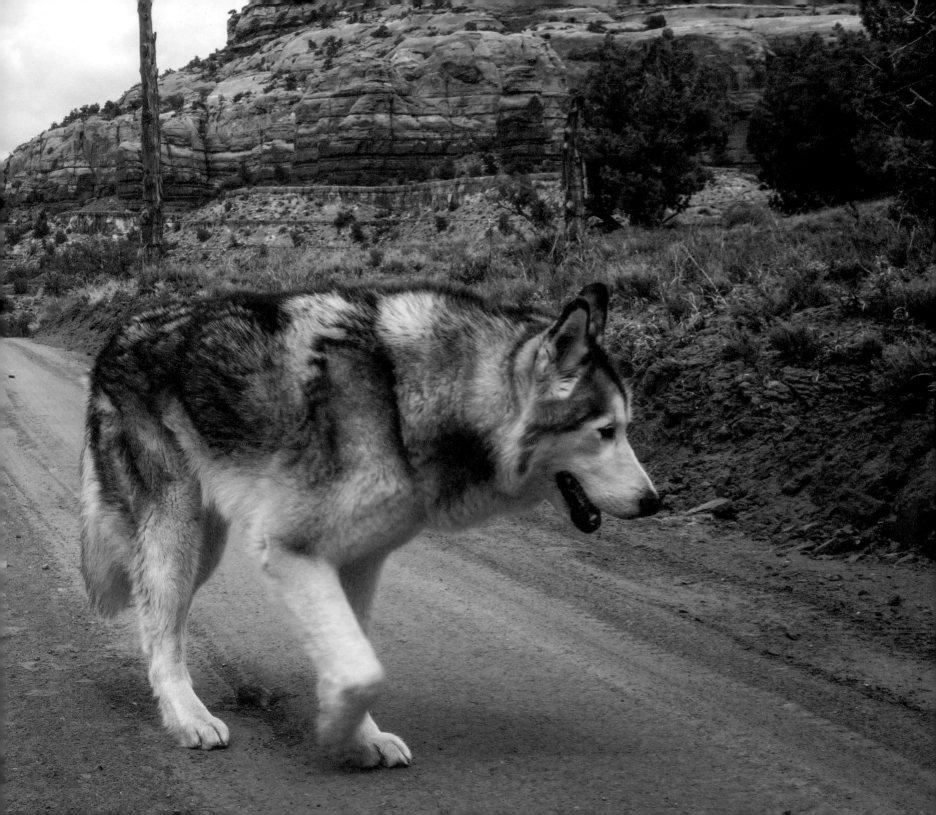

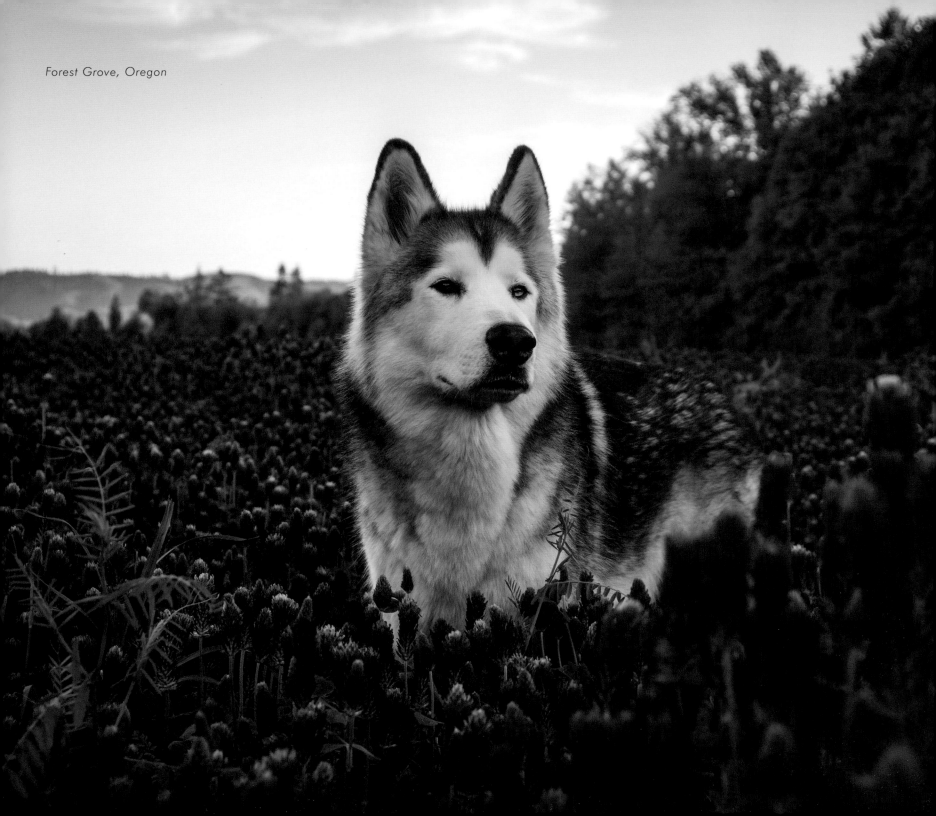

Forest Grove, Oregon

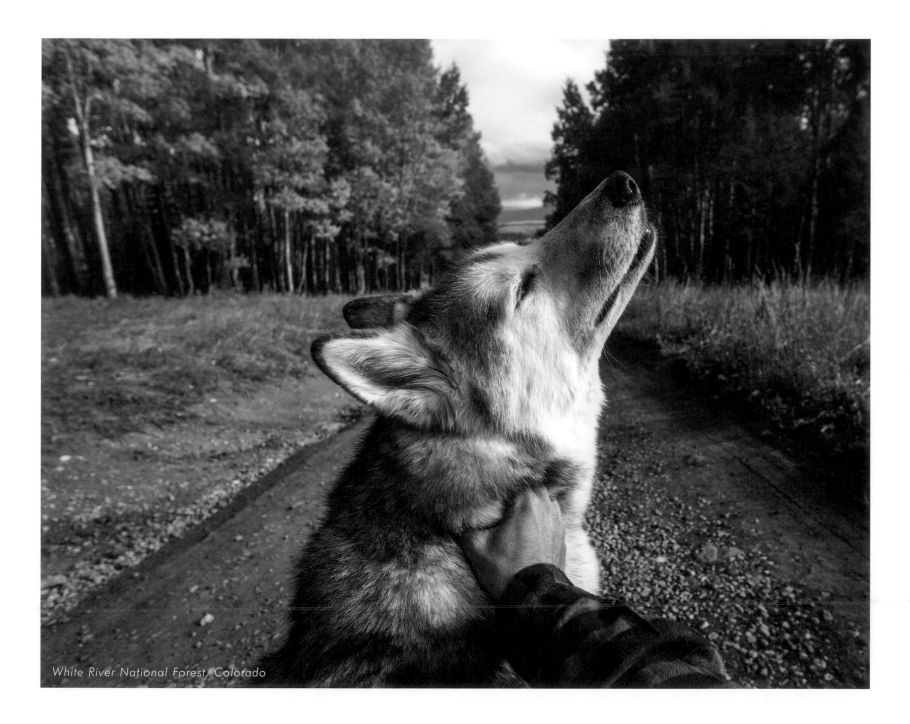

White River National Forest, Colorado

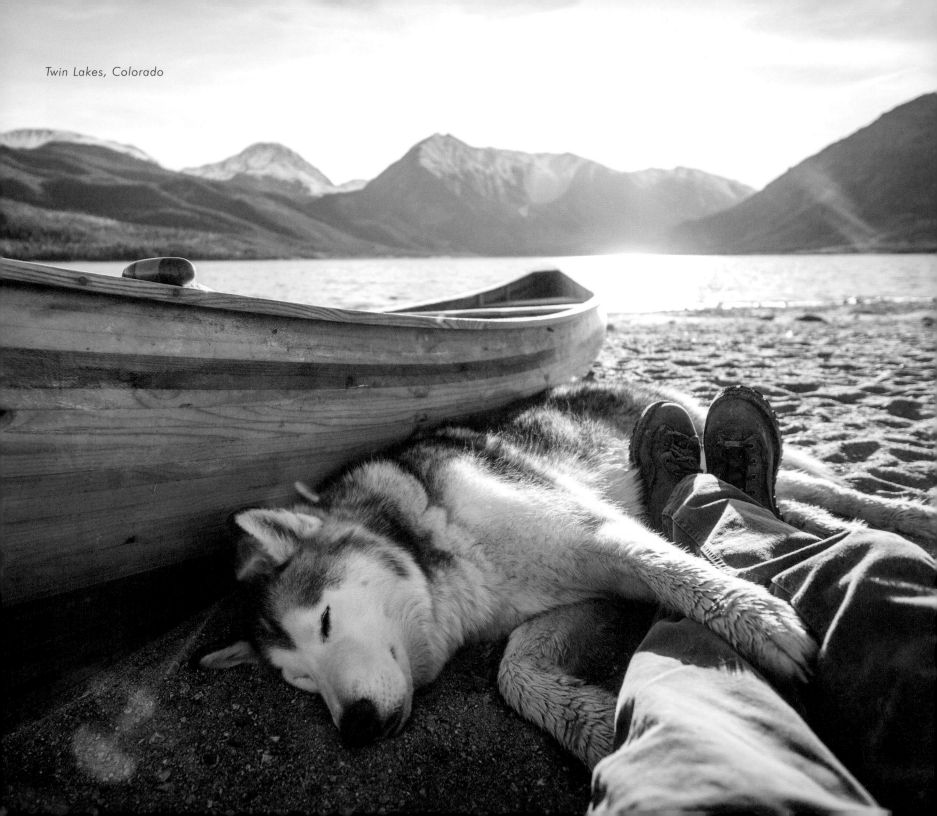

Twin Lakes, Colorado

The ancient art of rock stacking.

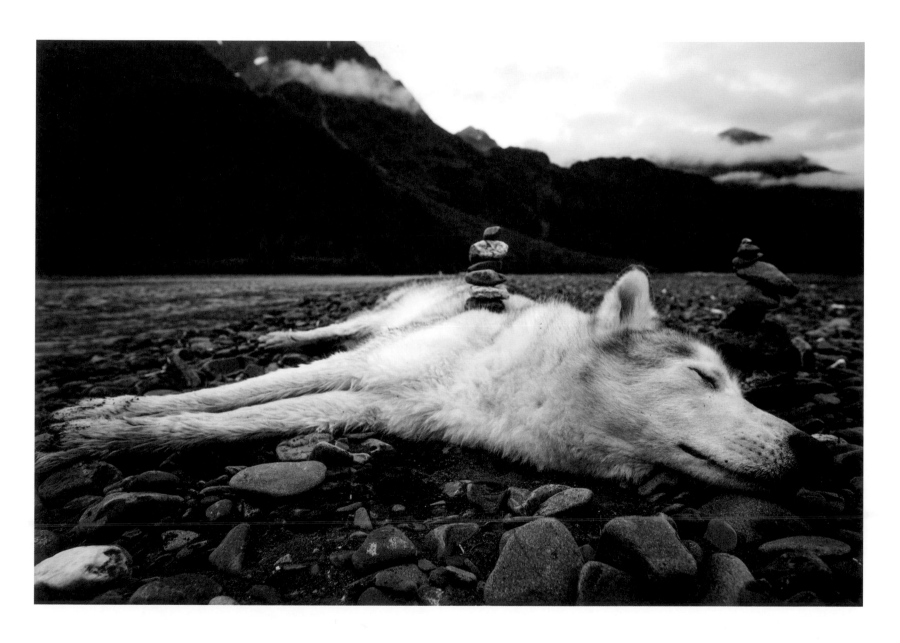

You Jump, I Jump

Being someone's best friend is a big job. One where you don't get a descriptive list of duties or a guidebook of how-tos. You can rely on how your parents raised you; to be kind, gentle, understanding, and helpful. All mixed together, no doubt there is a foundation for how to be a good friend to someone.

So if that's true, who taught dogs?

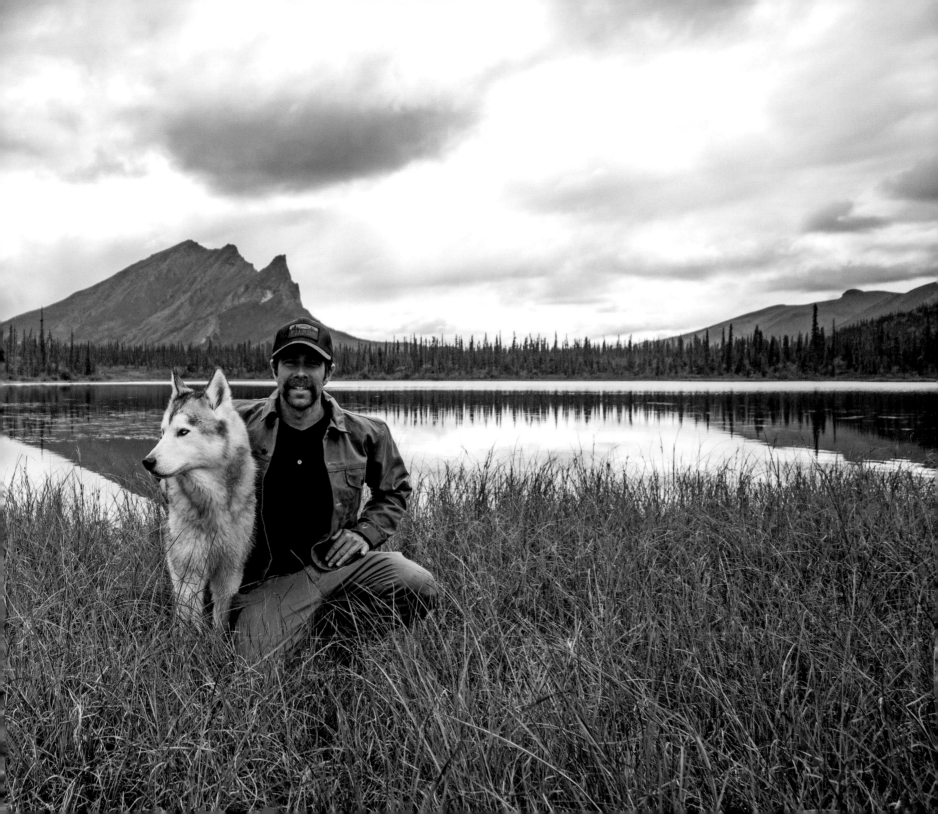

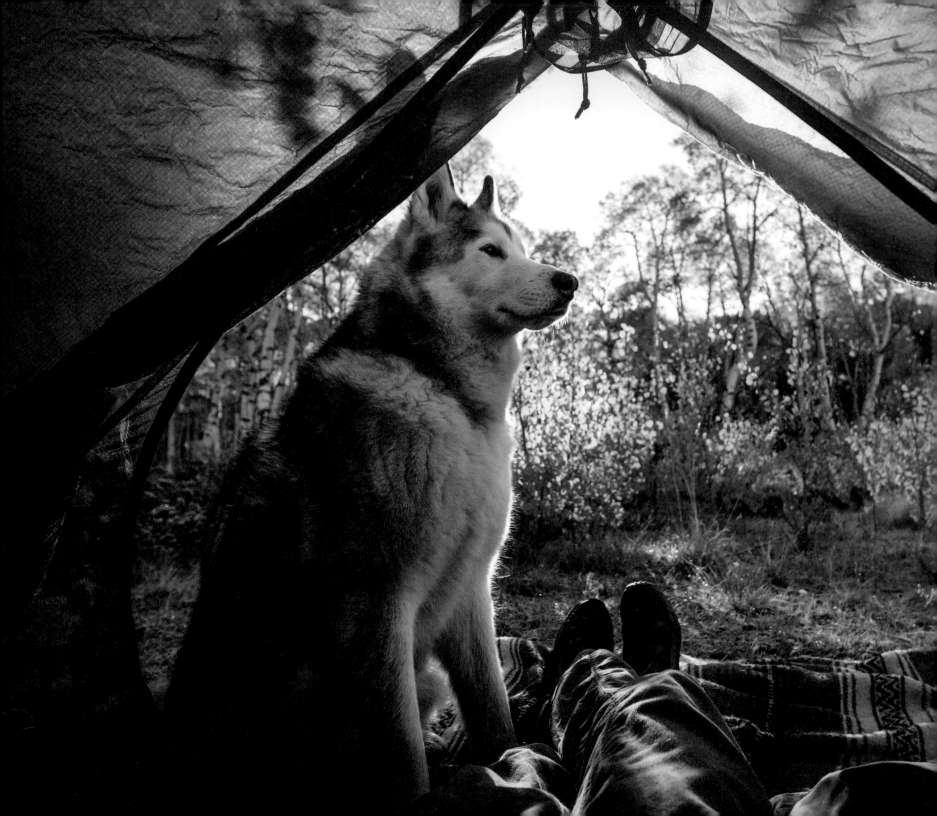

Dear Journal

They say you only take pictures of the things you don't want to forget. I have learned this to be true. All these years photographing Loki and our life together, I attempt to capture as much of the story as I can, with as few photographs as possible. If I can get the warmth of the light, the feeling of the earthy ground, and somehow capture the rhythmic heartbeats, only then have I been able to bottle the moment.

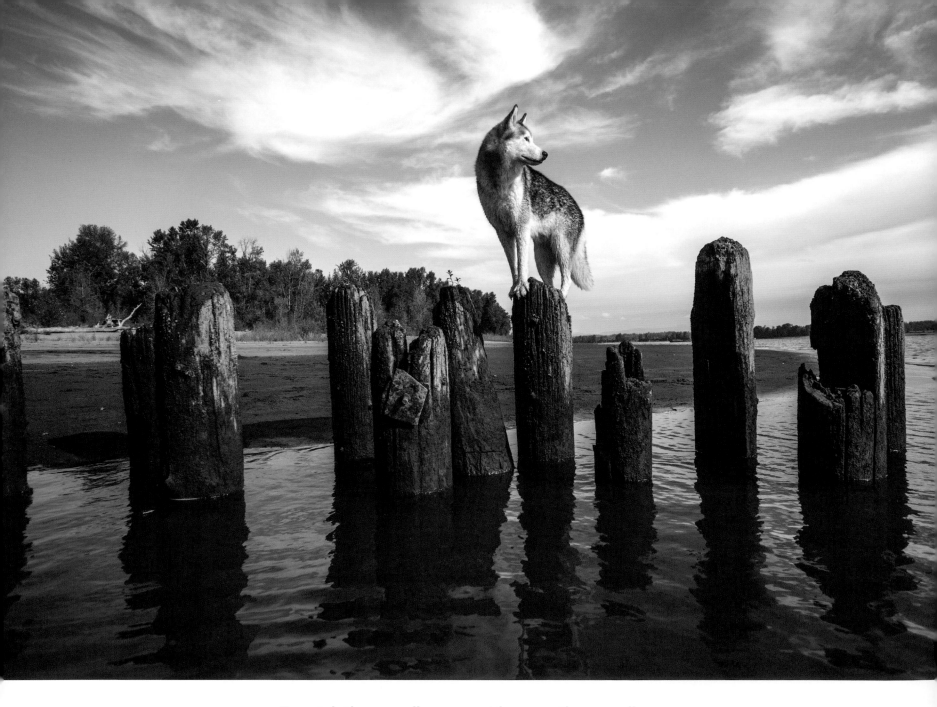

To catch the seagull, you must become the seagull.

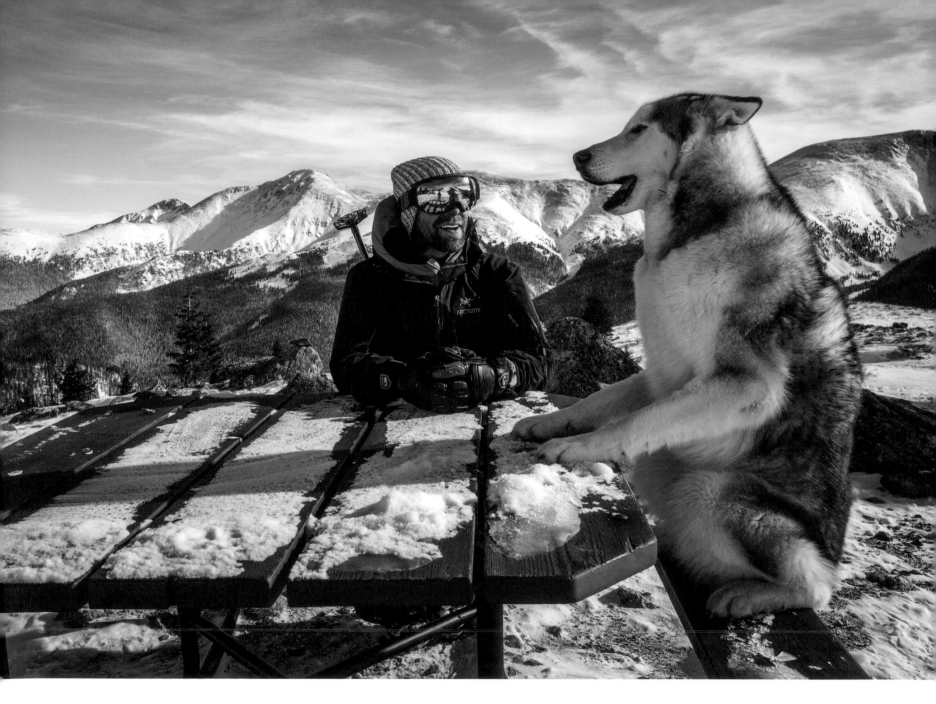

The Knights of the Picnic Table

How is This Work?

One time I saw something on the internet that said: "Do what you love and everything else will work out." So, I gave it a shot and laid on the couch all day eating pizza and taking selfies with my dog. Everything did not work out.

I am not a formally trained photographer. I didn't set out to become one. I just started taking pictures of Loki and sharing them on the internet. People from all over the world started to feel connected to him. It certainly could not have been about any skill or talent I possessed, but rather Loki's ability to communicate his spirit without words.

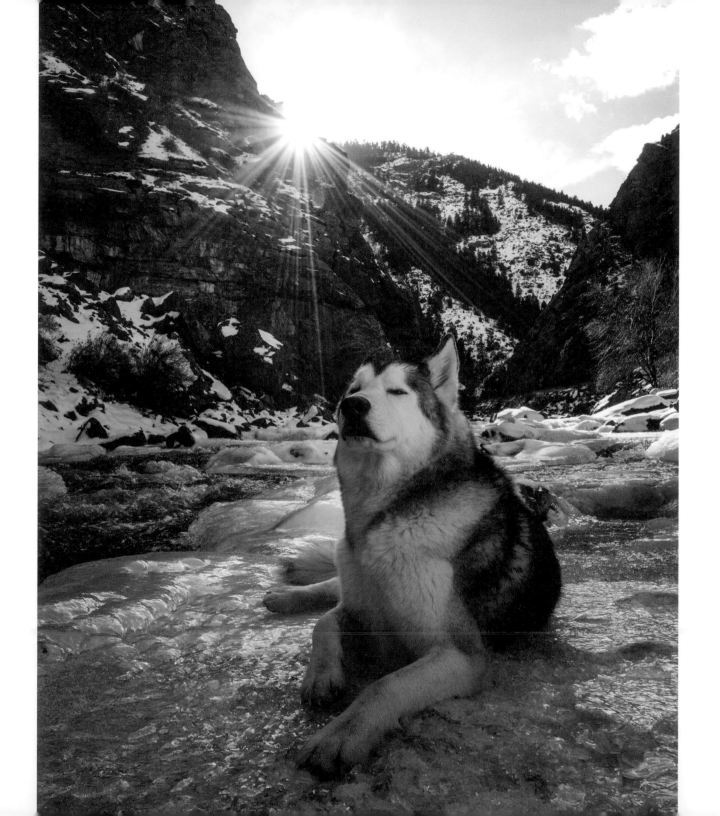

Follow the Leader

I think there are points in our lives where we are challenged to become a leader, but we either rise to the occasion or we say it's not for us and let someone else take the reins. For me, being a dog owner was one of those points. We have all seen dogs that are not well trained, disobedient, unruly, or just a handful in general.

Countless people ask me how Loki is so responsive and obedient.

I knew very early on that I had to be the leader out of the two of us. I had to instill in him that I am the decision maker and the alpha to his beta. I don't think any other structure works with an animal like Loki. It is my responsibility to show him my expectations and the rules he must follow. He may not like it in the moment, me seemingly prohibiting his freedom, but it is always to keep him safe and to keep order in our shared life. When I tell him to sit, to stay, to come, he knows he has to. Sometimes there are rewards, sometimes there are not. But underneath all the firmness, he has to know it comes from a place of love rather than control.

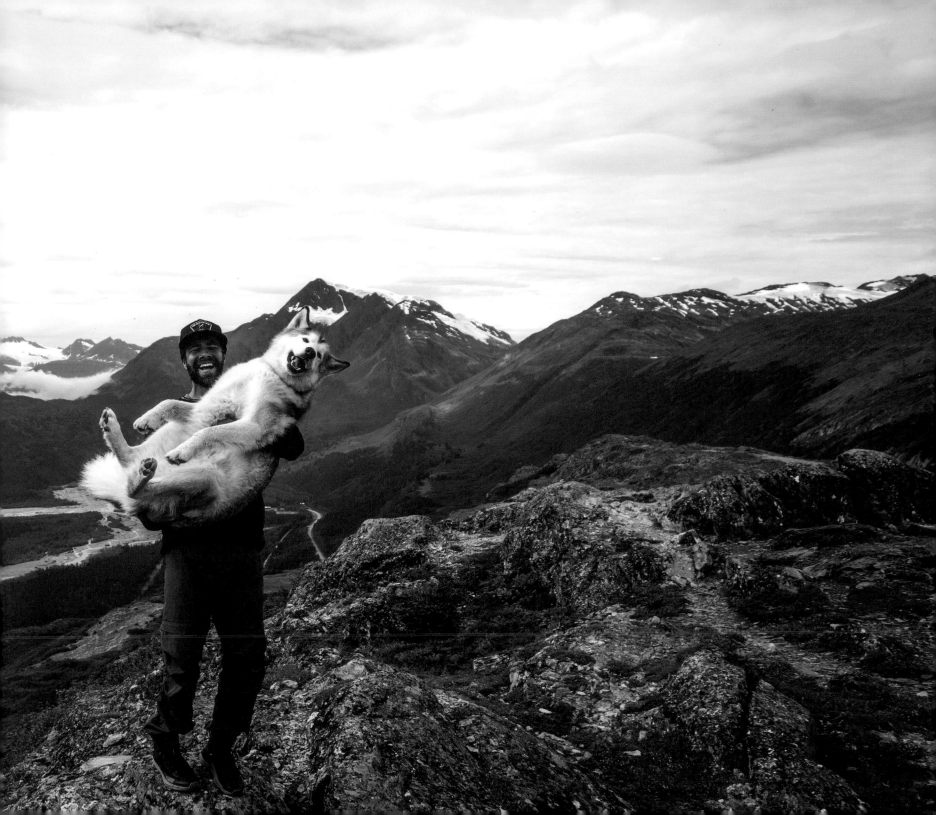

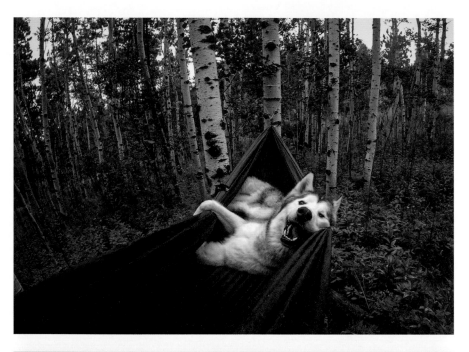

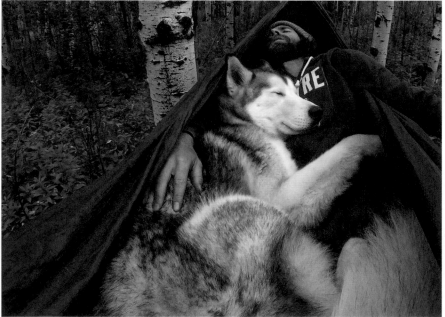

The Hammock Seen Around the World

This is it. This was the moment that sent us rocketing into the social media universe. I took the shot one-day after work when I was tired and dirty, I was not planning on capturing an image that would eventually change our life.

I shared it online, and the next morning it was picked up on Reddit. Shortly after, Bored Panda contacted me and wrote an article on us, followed by BuzzFeed. The months that followed were strange as our visibility grew, and I found hundreds of thousands of people were spending time with Loki and me, yet we had never met. Overnight, it felt as though the world's relationship to us had changed.

Genesee, Colorado

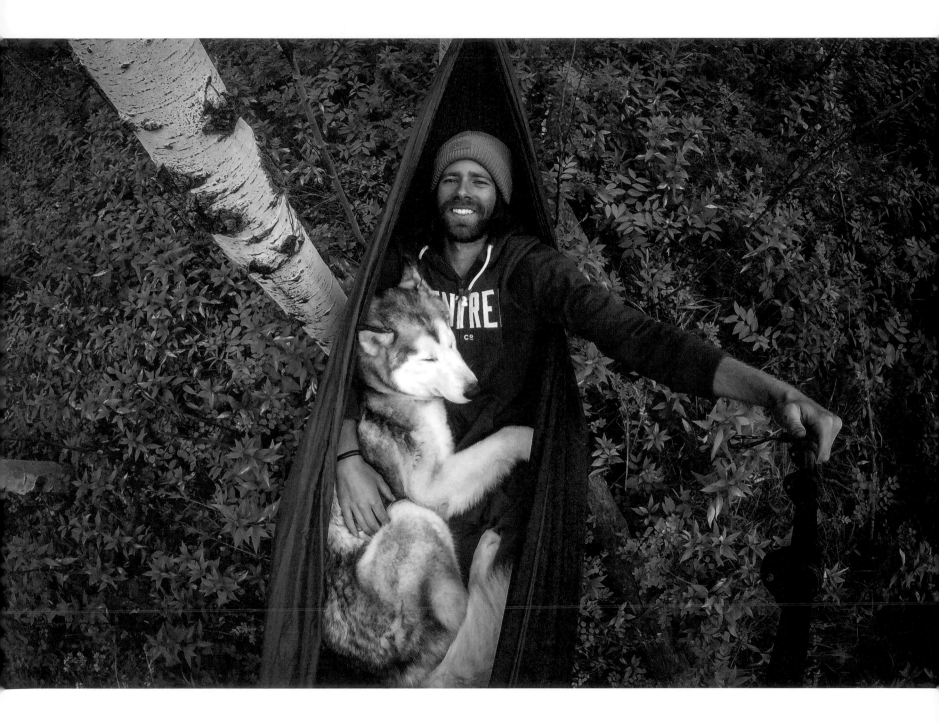

Eye See You

Almost every person that meets Loki comments on his eyes, or his eye, rather. Loki's left eye is partially blue. When people comment on how attractive of a dog he his, I kindly thank them, as if I had some hand in creating him. I smile to myself on the inside because I know how lucky I am to have had countless moments where I have seen how truly remarkable he is.

The snow is pounding down while we are in the backcountry; Loki is laying in the snow, patiently watching me. I am strapping into my snowboard and his eyes follow my movements but his head does not move. I stop to look at him, the snowflakes covering almost every place on his body. His eyes are burning. He knows we are about to take off at full speed down the mountain. He's looking to me for some signal that it's time. I hesitate because I want to remember him this way for just a little longer. His nose, black and wet. His fur, saturated, but still fluffy. His paws, buried in snow but eager. His ears, listening and curious. And finally his eyes, focused and ready.

I am so thankful for you, Bubs. Let's go.

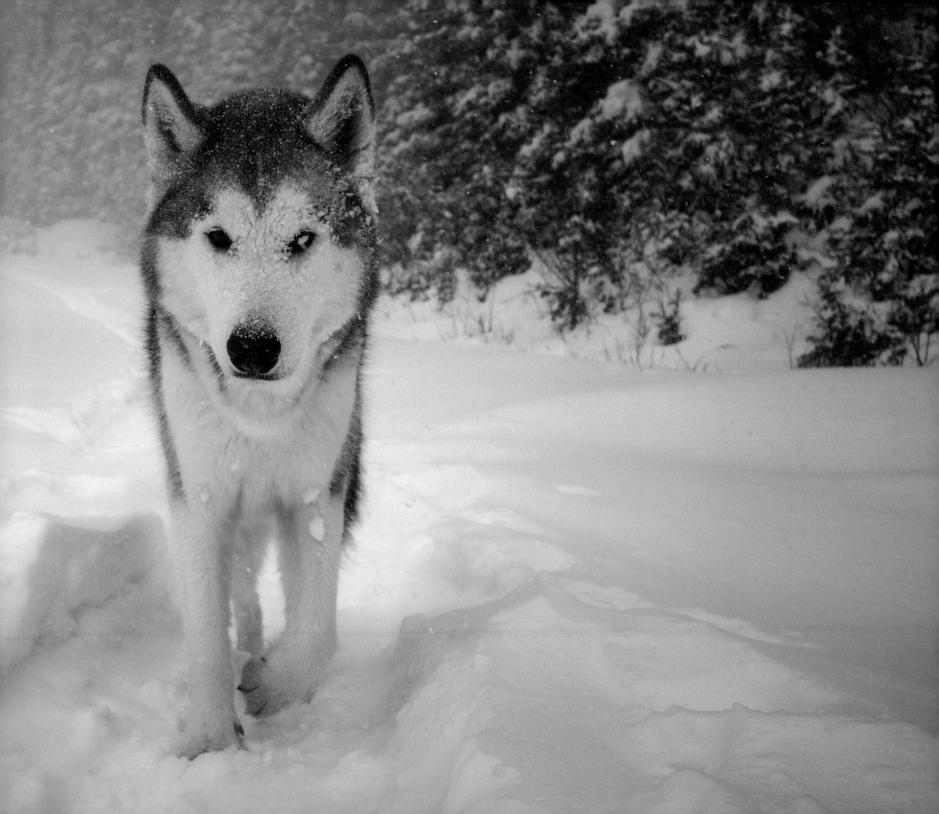

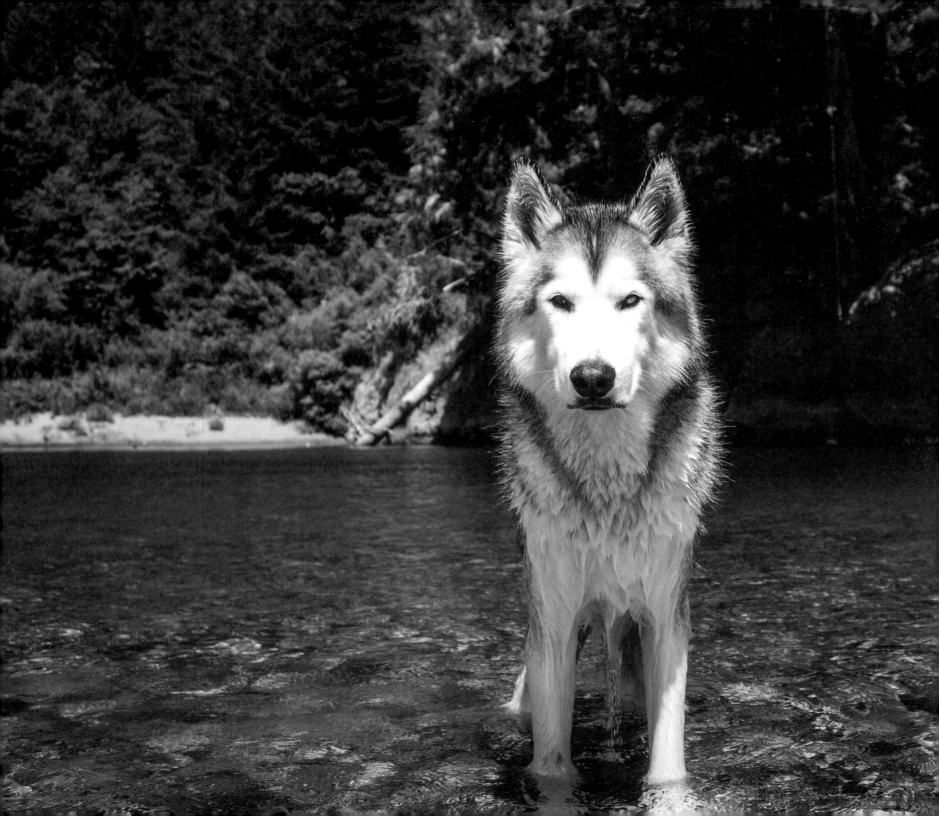

Harder, Better, Faster, Stronger

Loki will charge any element or environment. Rain, snow, freezing temperatures, mountain-tops, and barren desserts; you can almost hear the action-movie theme music playing in your head. He is a monster of muscle and speed with near perfect accuracy. I can't understand the calculations in his head when he's moving so fast without crashing into trees or falling off the rocky edge. When we get separated and he is in pursuit of me, I can sense the urgency in what sounds like a herd of horses pounding the ground. The chase is on.

It becomes audible how much he is a creature of the wilderness, one of Mother Nature's many sons.

The Smith River, California

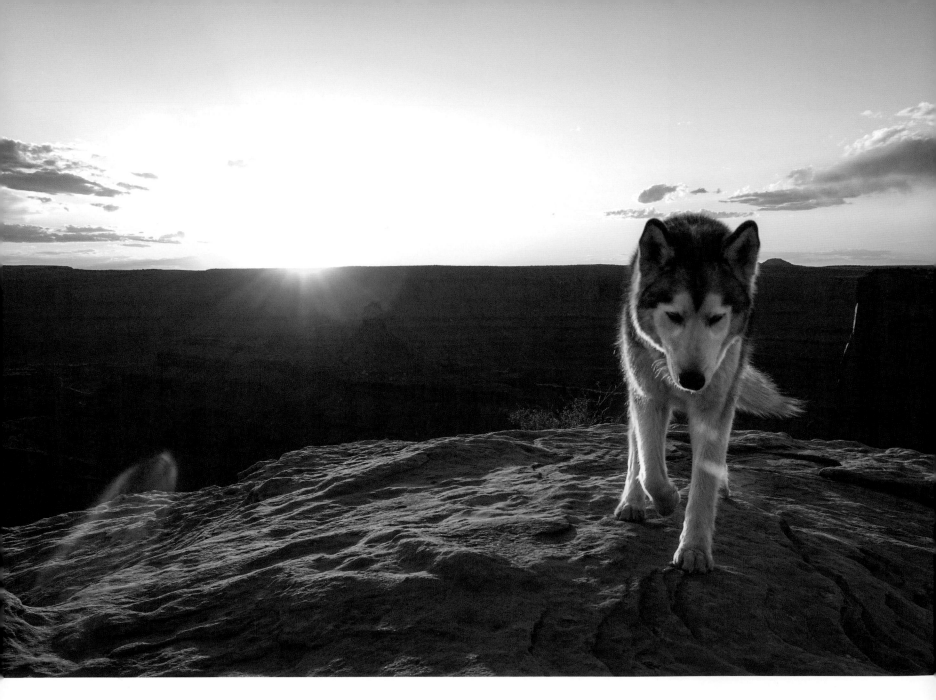

Tell me that forever is a real measure of time.

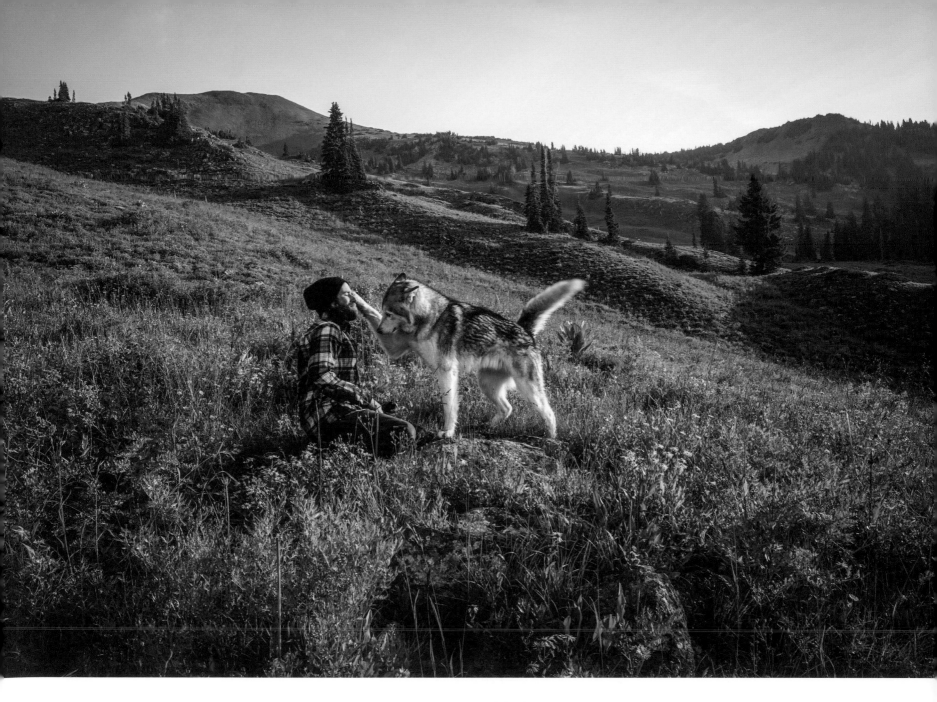

Secret handshake.

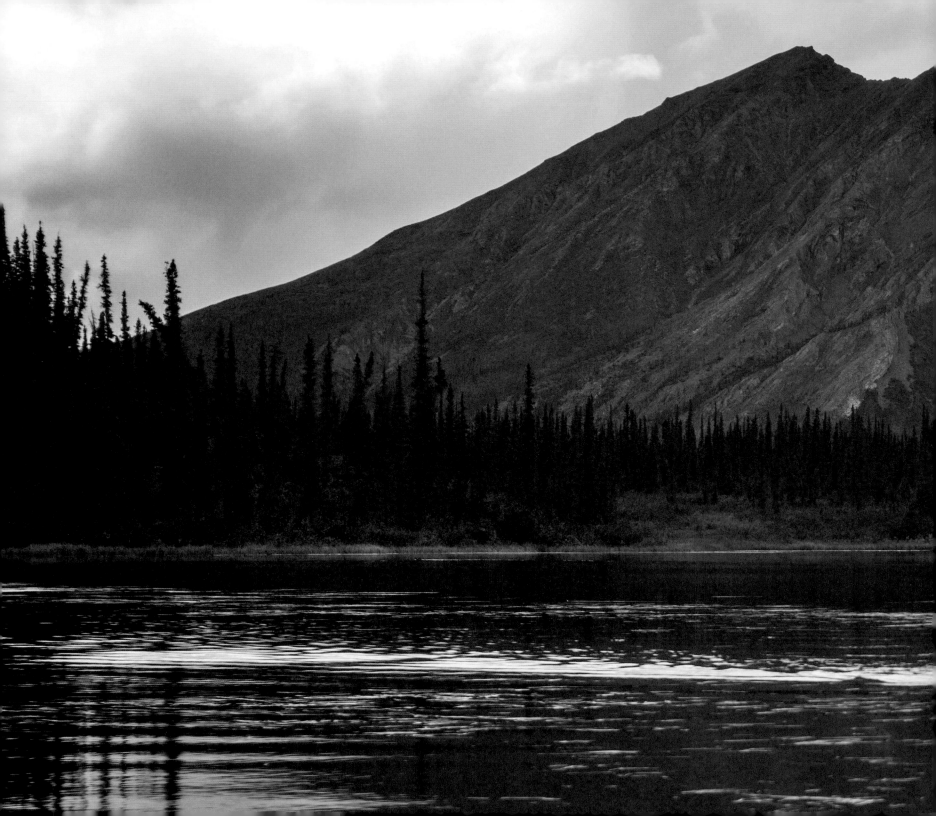

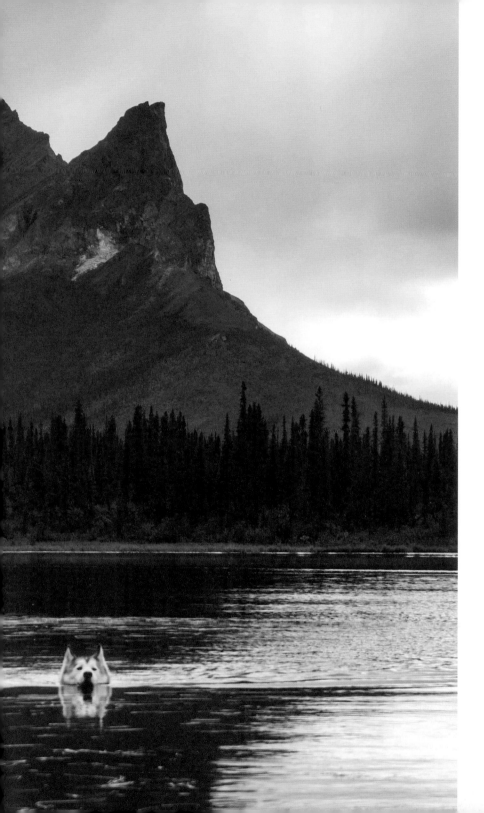

JOURNEY

I can feel the fire inside me burning.

Letting go of the past to push harder into the night, searching for what is ahead of us.

The fire builds.

Finding the courage to venture out, not knowing what is waiting.

The fire feels almost out of control.

I know he can feel it, too. I see it in his eyes. It fuses us together as we wander into the unknown.

Dad Knows Best

How did I get Loki into a helicopter? This is the best answer I have.

All of Loki's life I have tried to expose him to as many things as possible. We go different places, with different people, other animals, new scenery, and new experiences. I told myself that the more he knows, the more he grows.

Fear typically comes from the unknown and not knowing if you will be safe. Like all beings, dogs feel fear and typically respond with fight or flight. Since we are rarely apart, the majority of instances where Loki feels fear, I am there with him. His body language changes; his ears go back, his eyes drop, and he hides and turns in to me seeking refuge.

This is the moment I can use to teach him something new. There is no fear here, sense me, sense my body language, do not be afraid. The more I can teach him this, the more trust we have. I show him a situation is not to be feared, but to be fascinated by. Learn this new noise or learn this new smell, know that this will not harm you. Admittedly, these moments occurred more so in his puppy years when almost everything was a new experience. The trust we built in those years has come back ten-fold because he hopped into a helicopter like it was the pick-up truck we've covered so many miles in. And then we took to the skies.

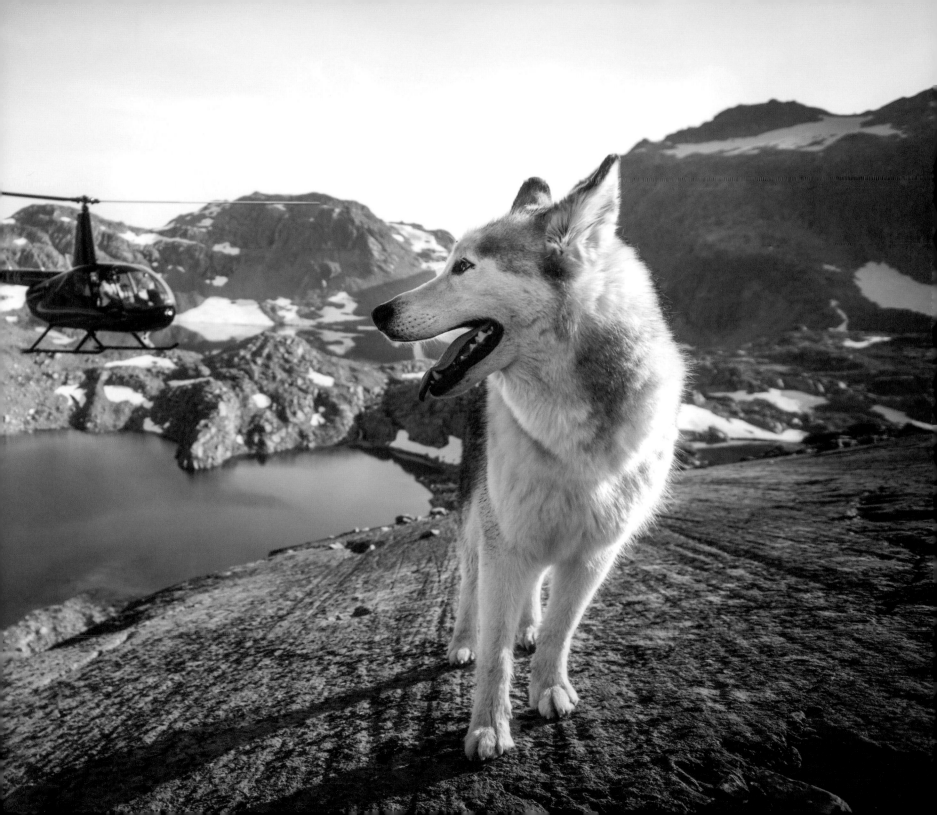

Be very, very quiet; we are hunting mosquitos.

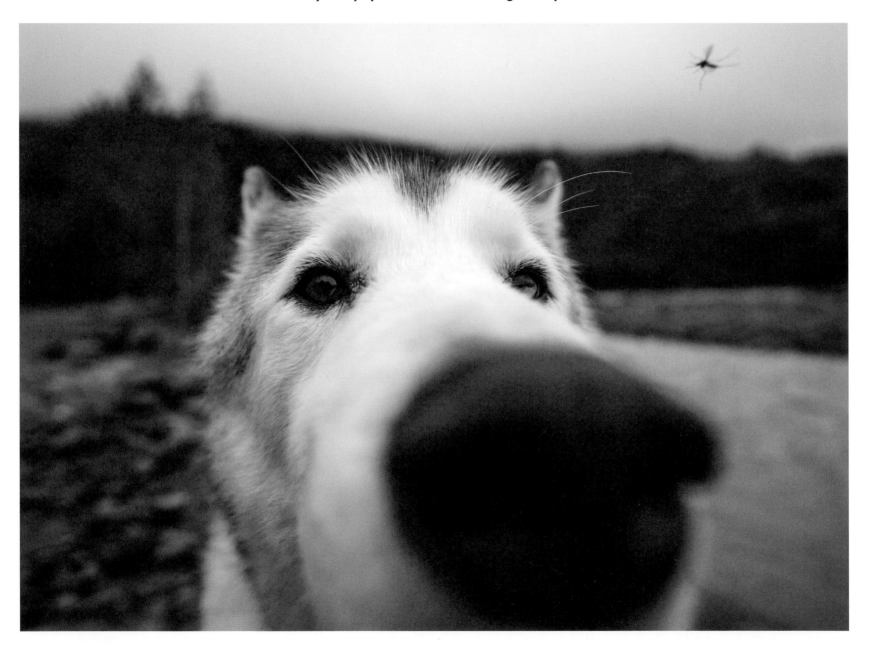

Drive Slow, Dogs at Play

Sometimes I am moving so fast, trying to get somewhere I don't even know. Trying to get to the moment I think is ahead, but what if I am missing what is right in front of me, in this moment? It flies over my shoulder at light speed and it's gone; I turn around to see the tail end of it, it's just not the same. I can't go back and recreate it, or try to mimic it in a photograph.

The present is all we have, no one is promised the future, and we cannot change the past. I want to live my life in the present, and I never want to do anything to rob Loki of the same. So I let him chase the occasional squirrel, share my ice cream cone, and sleep on the bed when he is muddy. Why the hell not?

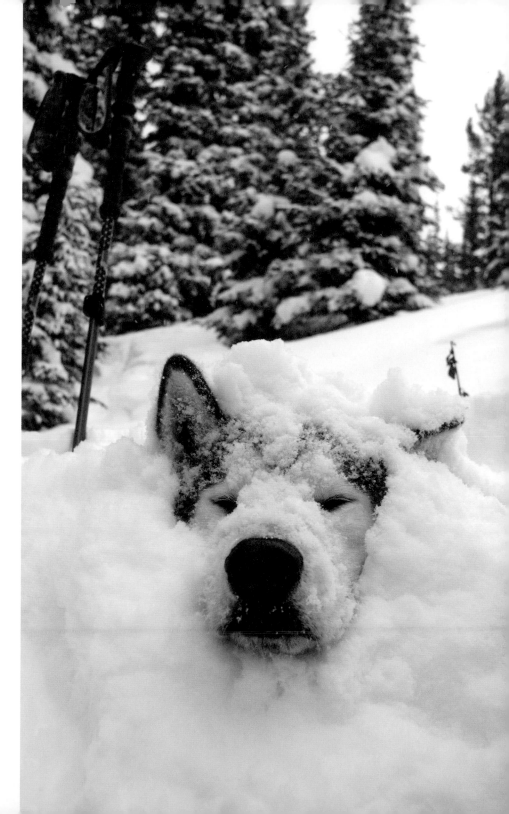

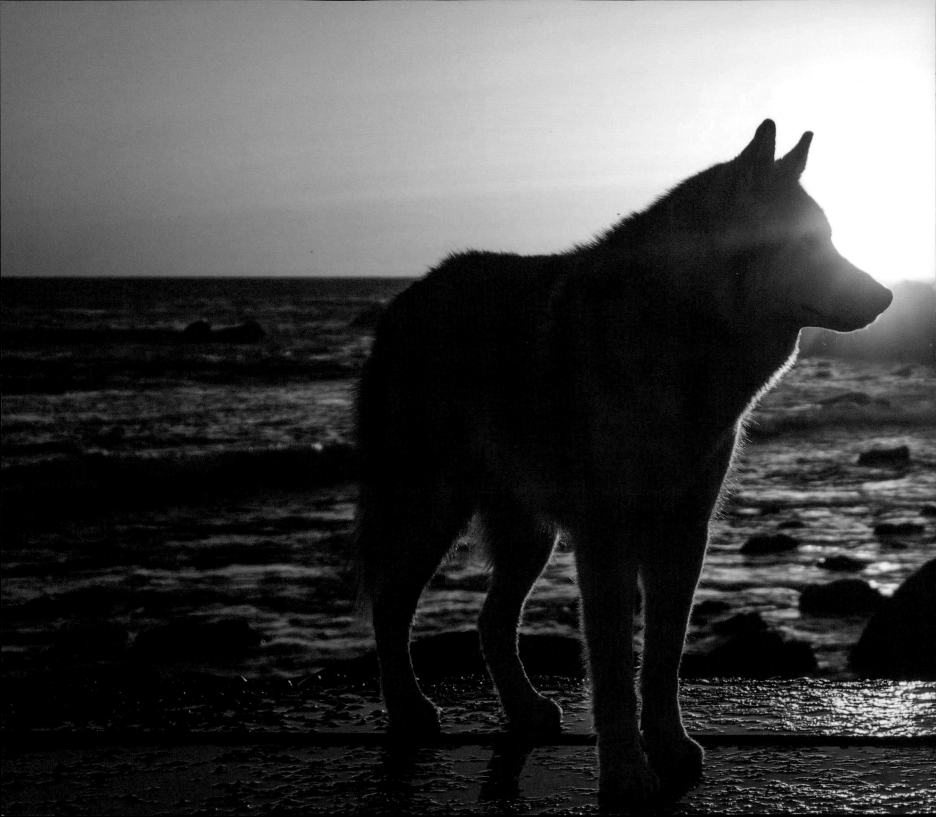

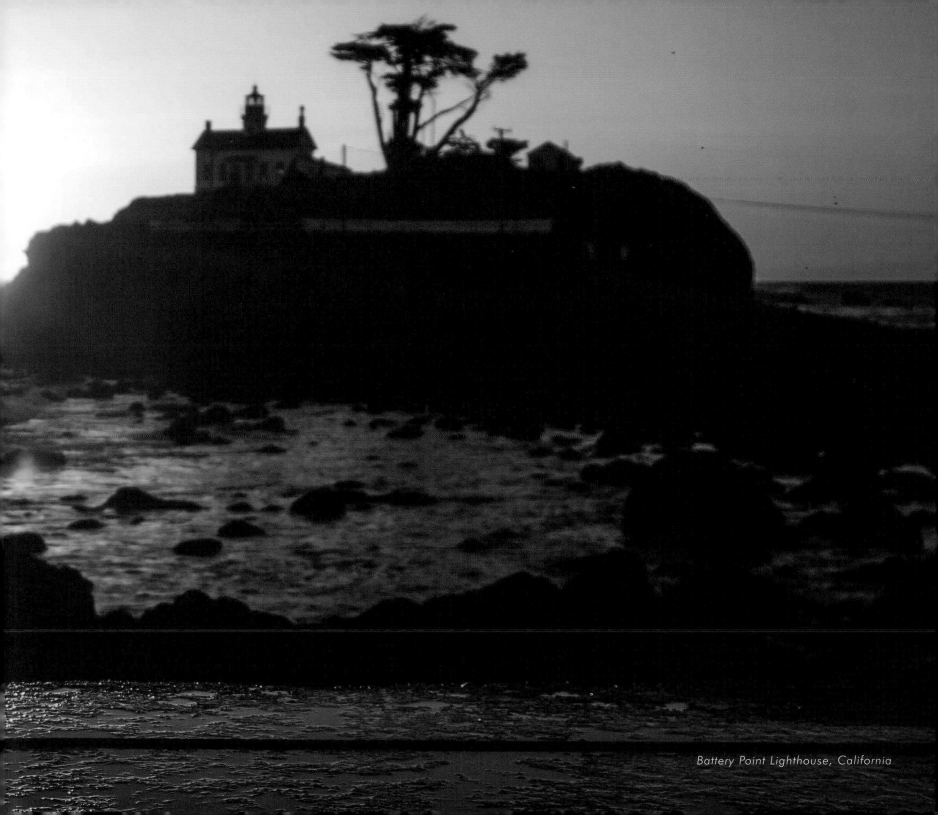

Battery Point Lighthouse, California

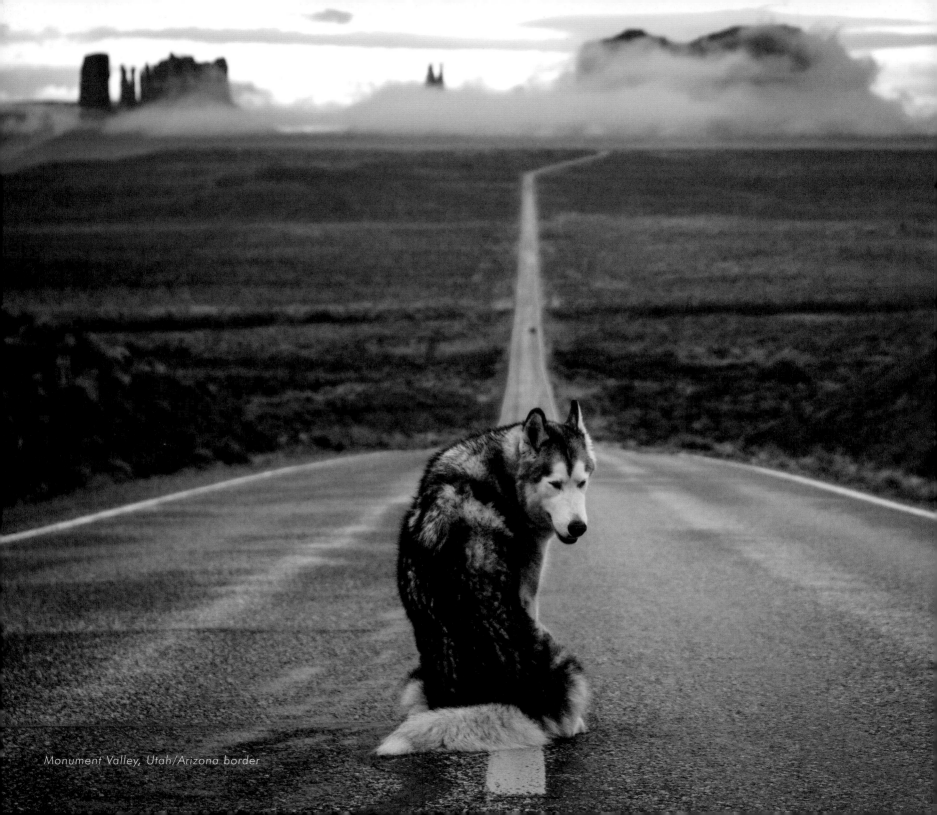
Monument Valley, Utah/Arizona border

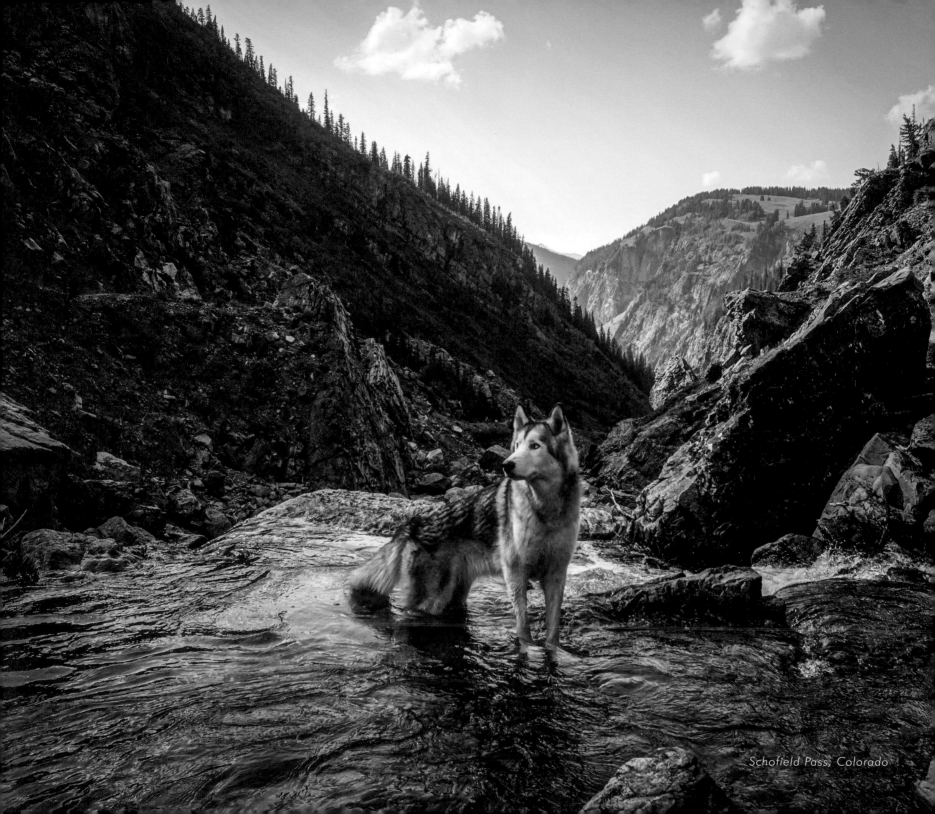

Schofield Pass, Colorado

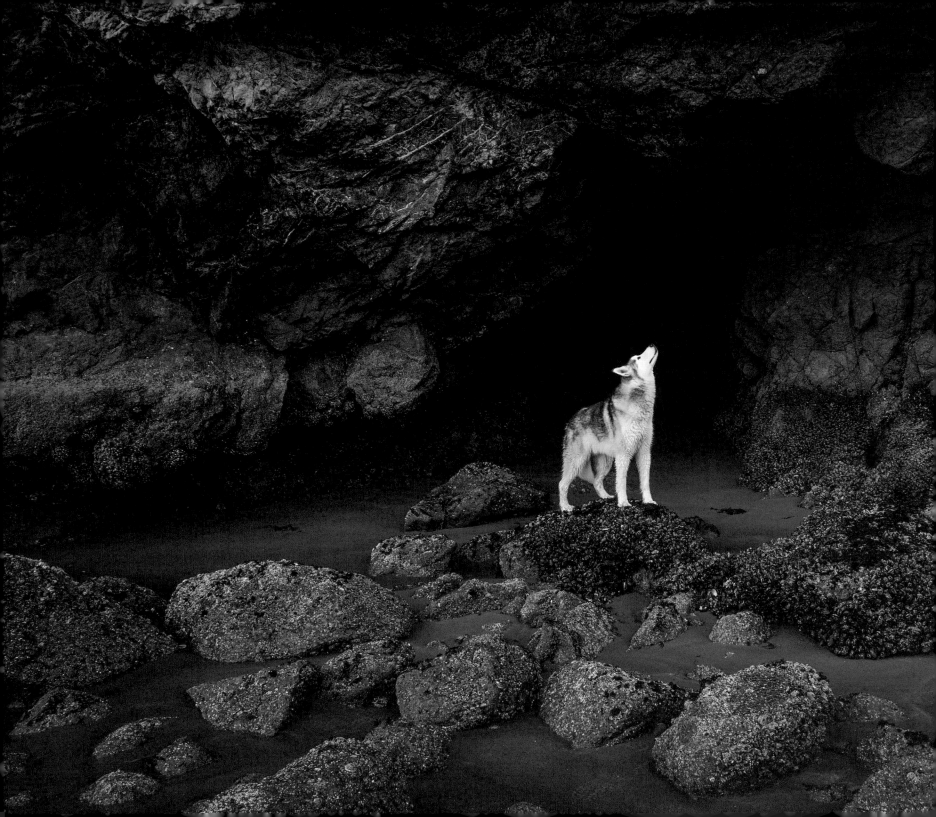

Man in the Moon

Someone could knock on the front door for an hour, and Loki would just stare at the visitor. I've never heard him bark, I don't even know what it would sound like. However, if you get him excited or inquisitive, he will howl. Ahwoooo. He's talking to the moon.

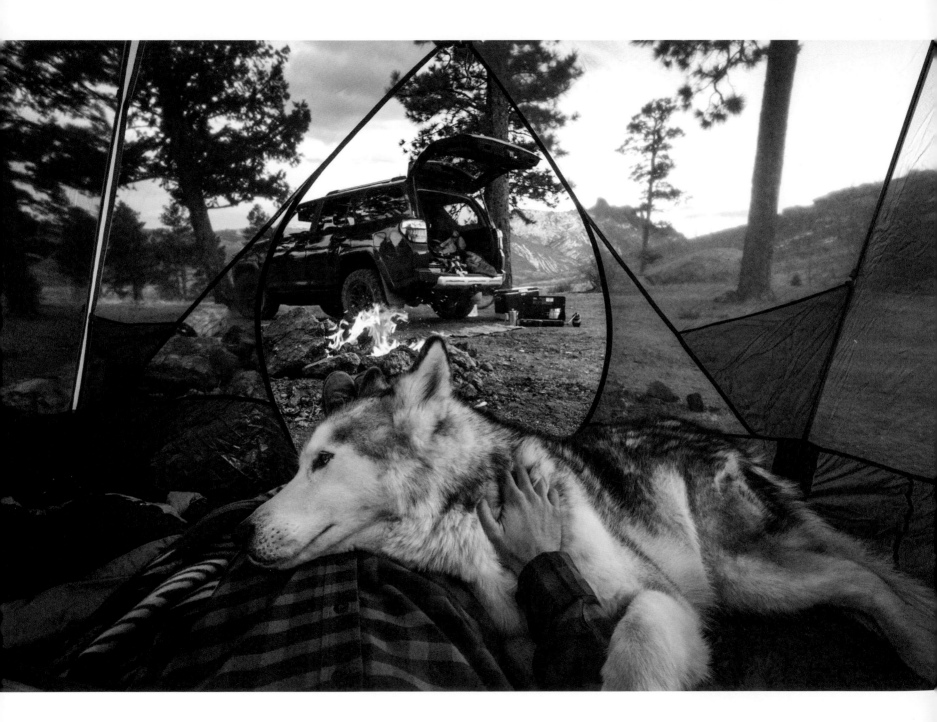

I'm Not Lost

Back roads are our forte. We go miles and miles down forest service roads not knowing where they lead. Sometimes they end in a logging operation, and we have to turn around. Some times they just end, *Wait, where was the secret treasure?* And sometimes, we get lucky.

We pull through a clearing and there it is. The golden ticket of camp spots. Someone has left us a fire ring, it tells us to stay awhile. The view is wide and vast. I can see for miles and I feel we are the only ones here. Loki is exploring the surroundings, and I start to unpack our home for the night. I know the sun is setting soon as I finish up with the tent and start making dinner. I call for him, he slowly makes way through the woods, and I see his face.

We sit down in the tent; doors open, and together watch the sun go down. I remember I had no idea where we were going earlier, and I really don't know exactly where we are now. This is how it's meant to be. This is where we're supposed to be.

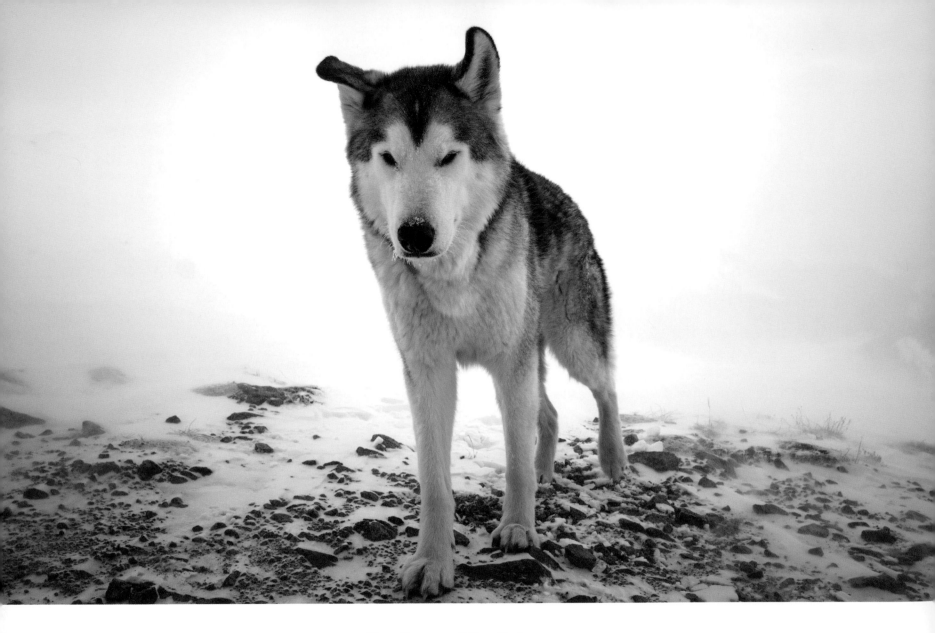

Our Corner of the Universe

I am going to tell myself that we are the only ones to ever be here. No one has ever stood here. No one has ever felt the sun from here, or the cold wind blow.

We shall not cease from exploration,
and the end of all our exploring will be to arrive
where we started and know the place for the first time.
—T. S. Eliot, "Little Gidding" in Four Quartets

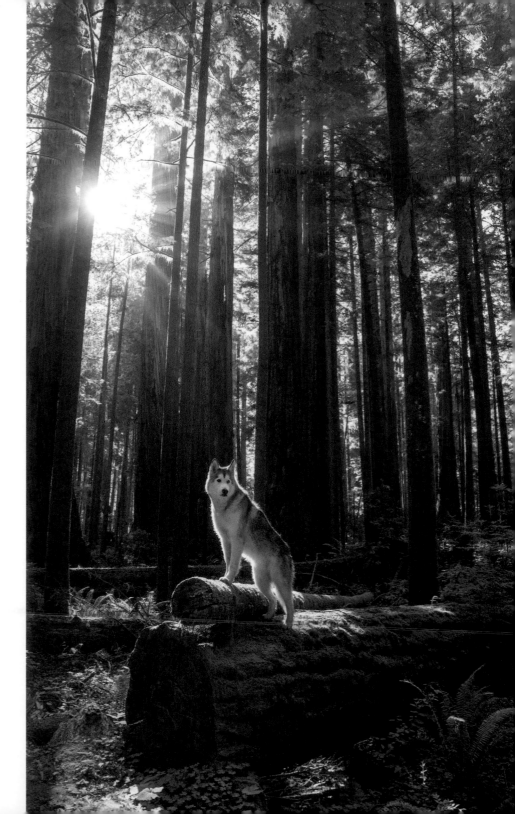

Goin' Down the Only Road I've Ever Known

Loki is his own dog. He makes decisions and has his own desires in life. It is undeniable, after watching him for all these years, that his mind consists of complex thoughts and emotions. He can go from being your cozy housemate to hunting small animals in the woods in seconds.

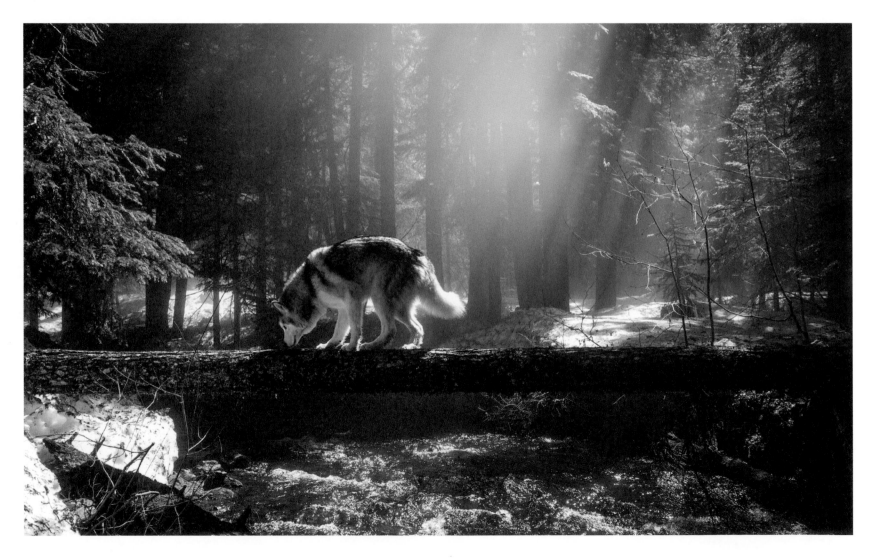

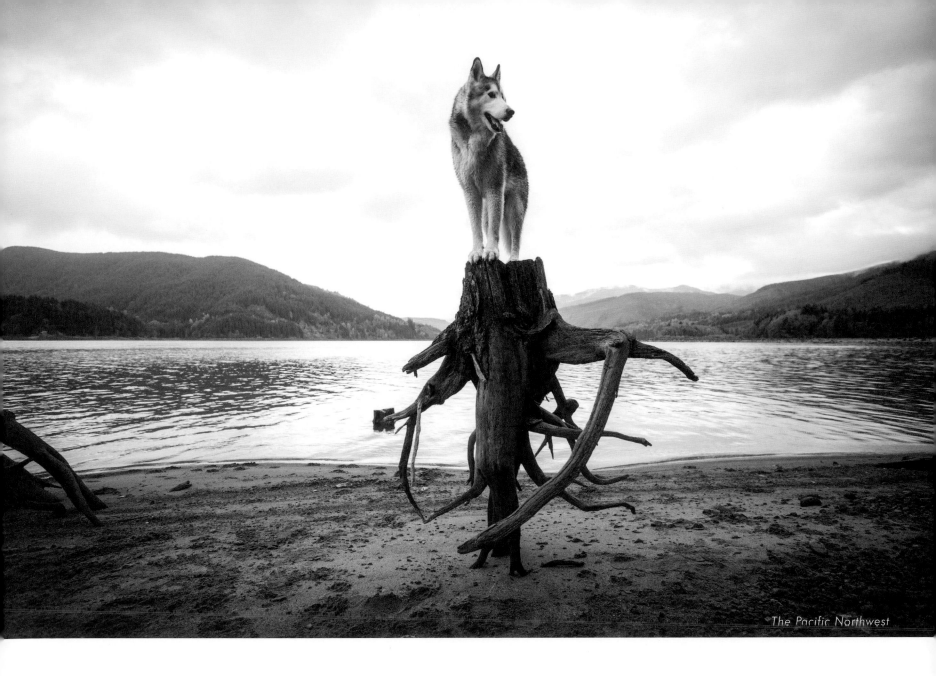

The Pacific Northwest

Stranger things have stumped me.

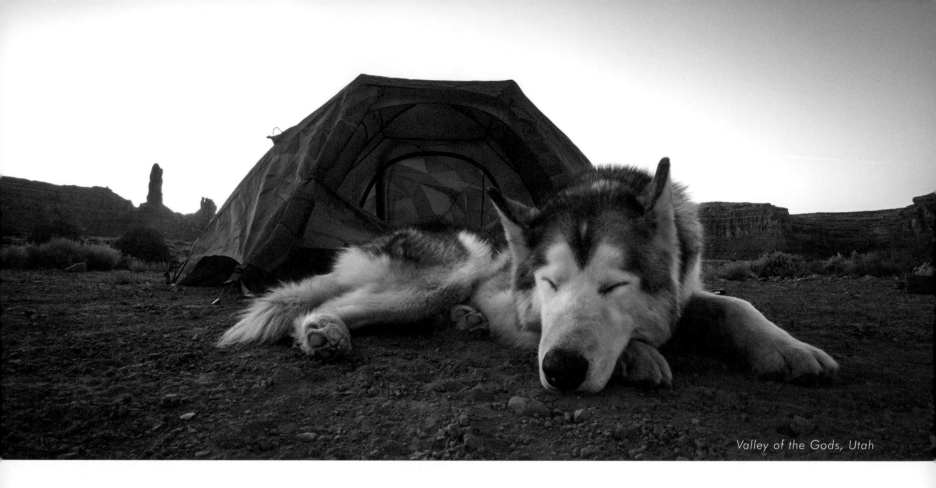

Valley of the Gods, Utah

Red Riding Hood

I look at this sleeping beast next to me, and I notice his paws. As Loki has become older, you can see the experience in his paws. They are tough and worn in some places. In others, they are soft and unscathed; I can feel the difference as I run my fingers around his paw pads.

His ears are like something out of a fairytale. They are soft and perfect in shape and design. He controls their every move; how, I don't know, it is most likely magic.

His fur is thick and fuzzy. He is like a puppy still in this way. I run my fingers through it and watch the patterns of color change as I move it around.

As I look at his teeth I think, *My what big teeth you have . . .*

Safety First

Being protected is not always simply a physical action. Feeling safe is not a tangible emotion. What a responsibility it is to love something. To give your all, to vow to be there, and to love unconditionally, what an honorable task.

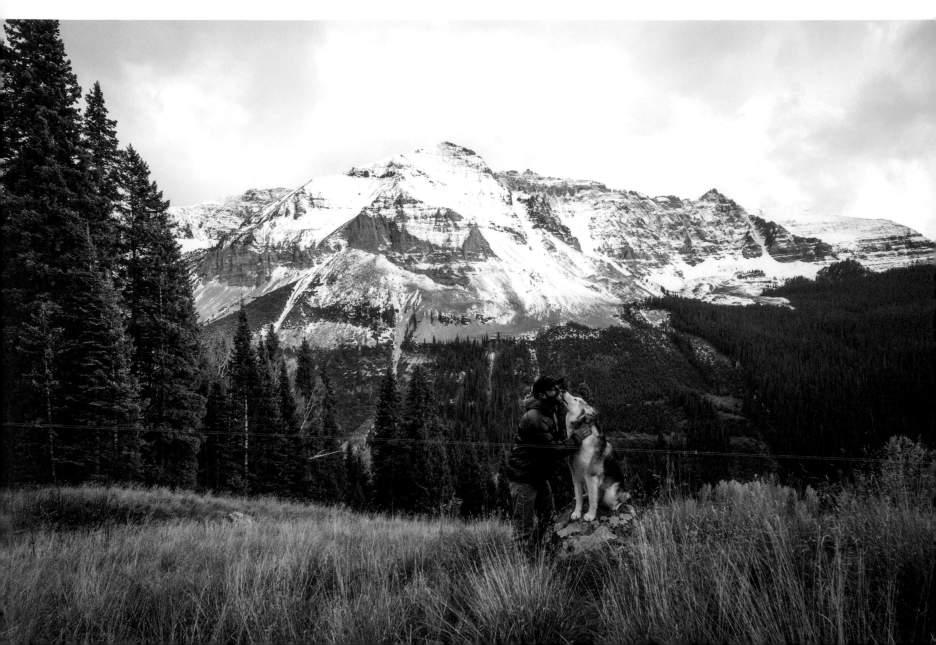

The Shortest Distance Between Two Points

The alpha female of a timber wolf pack will lead the way through deep snow while tracking prey. Every wolf in the pack will follow in her tracks, in a straight line. They do this to conserve energy for the hunt.

While there are moments where he is a normal dog, sprinting around in irrational patterns, Loki can often times be found just walking or running in that straight line. He is waiting for something to deviate him from that path that he is on.

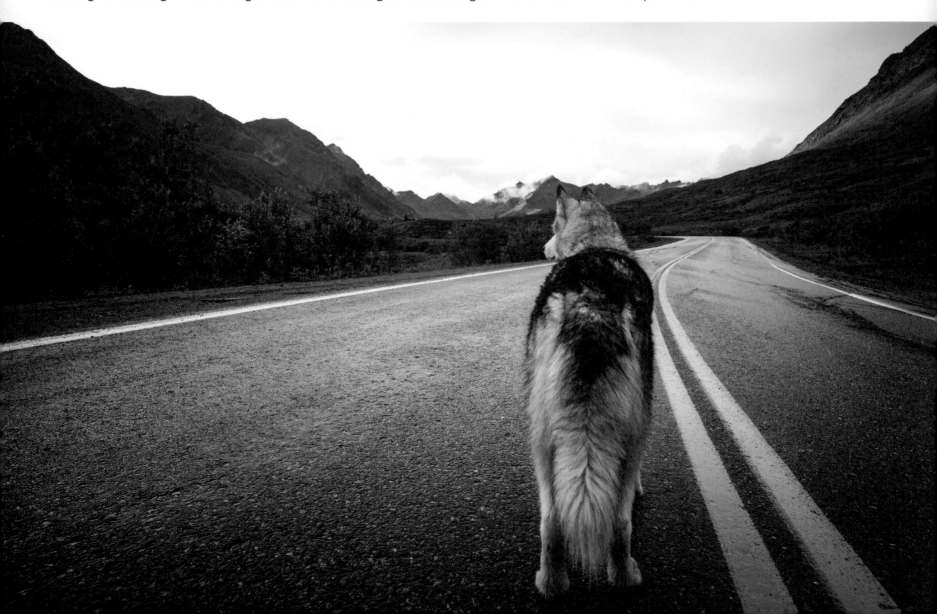

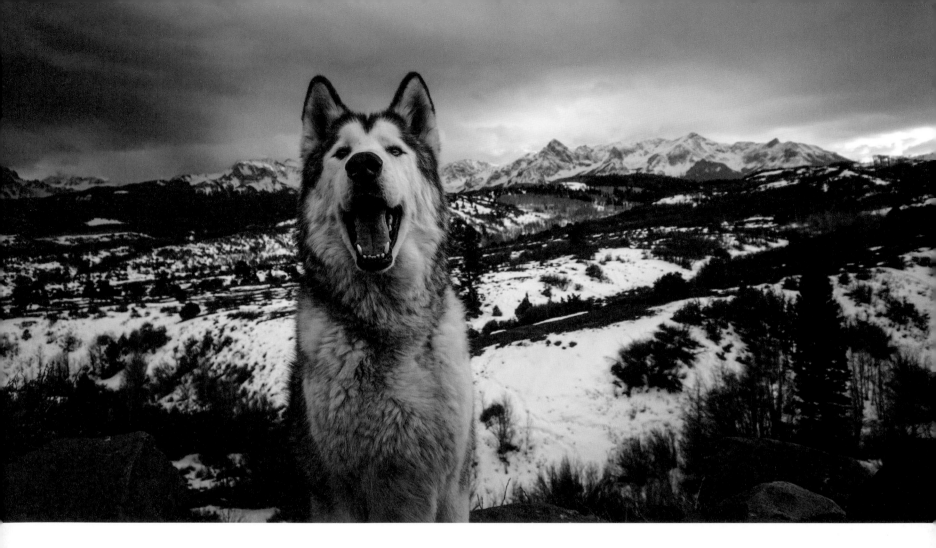

Recipe for Dog Happiness

2.5 hours of driving
1 set of skis
1 fuzzy canine
Add snow
And chill.

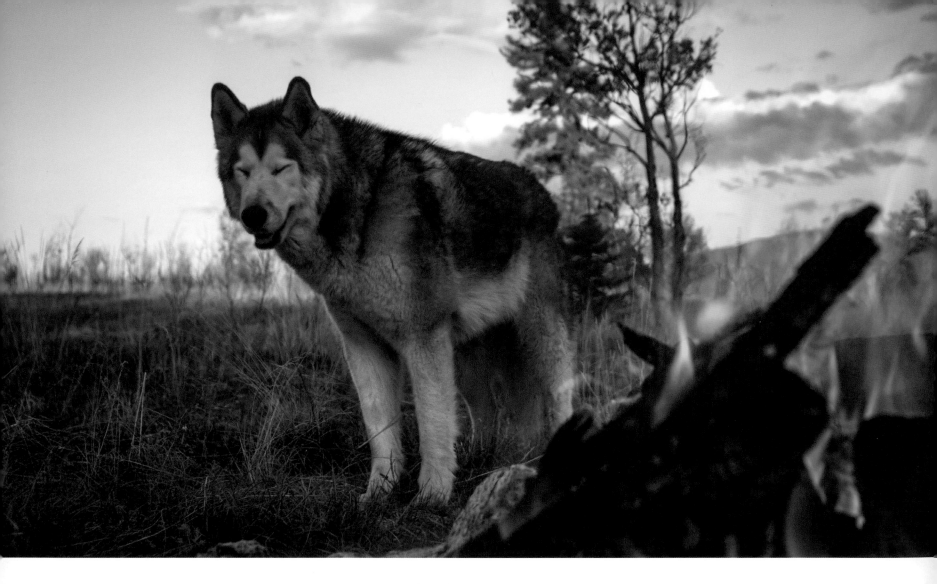

As Good As it Gets

We pull over just before sunset to set up camp. He wanders around a little while I routinely unpack. We get in the tent just as the sun is saying goodbye, I think of it as nature's nightlight.

Loki lays his head down watching the final golden moments. I gently scratch behind his ears and realize this field is better than any five-star resort.

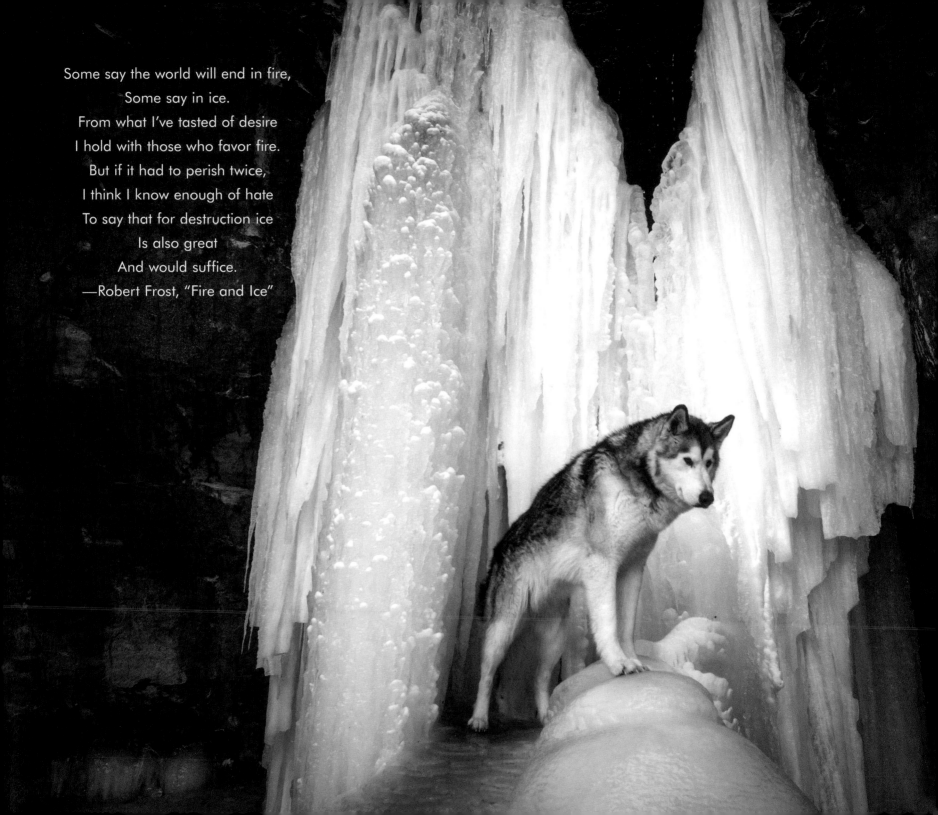

Some say the world will end in fire,
Some say in ice.
From what I've tasted of desire
I hold with those who favor fire.
But if it had to perish twice,
I think I know enough of hate
To say that for destruction ice
Is also great
And would suffice.
—Robert Frost, "Fire and Ice"

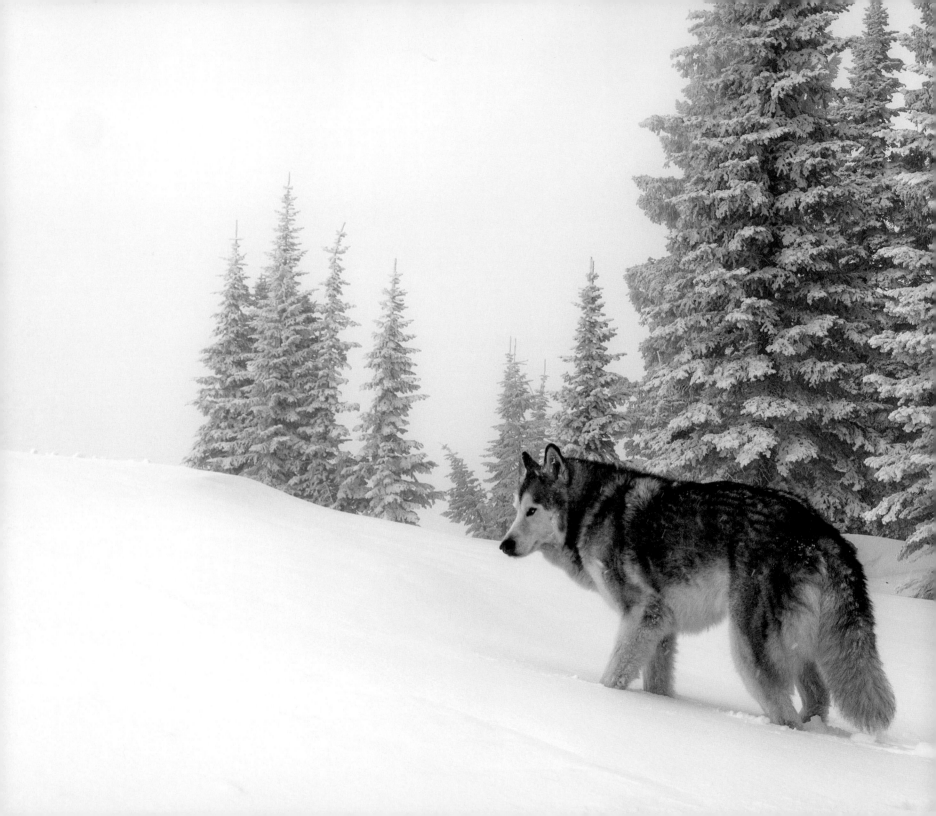

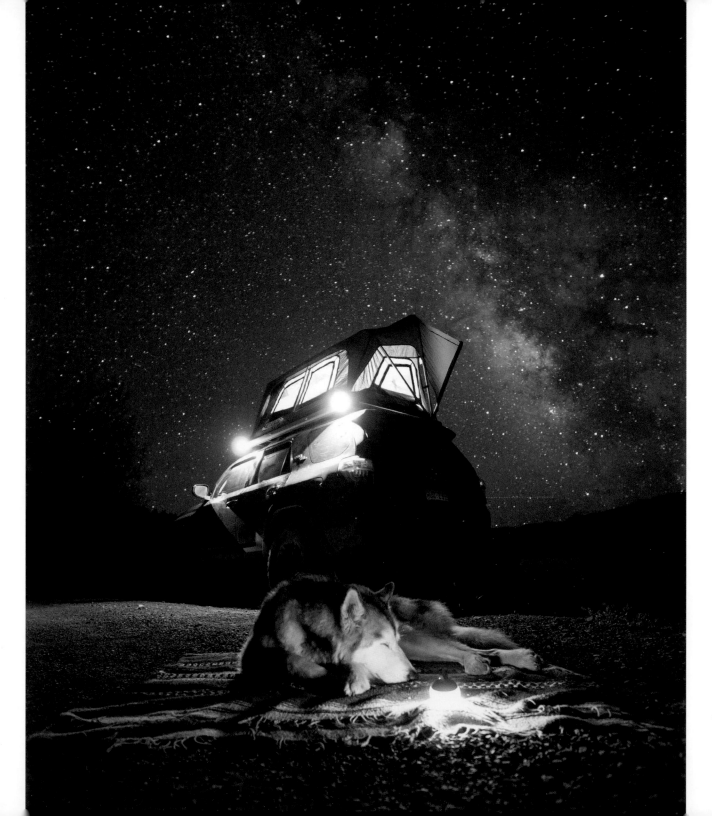

Planet Earth

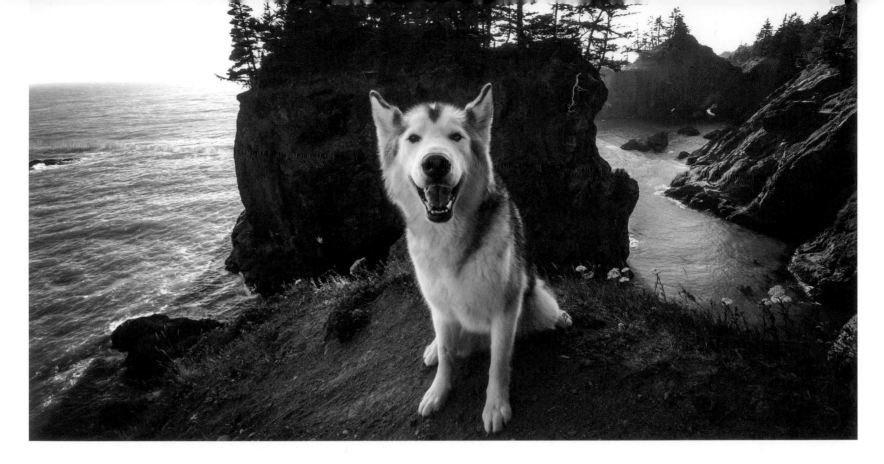

Home Alone

Leaving Loki behind at home is really not a viable option. He wants to terrorize the interior, and if left alone to his own volition in the backyard, he will try to escape. When I first got Loki, I had a housemate that was home a lot to watch him, but when that living situation changed, so did our daily life.

I would run him in the morning, give him a beef bone, and pray he wouldn't escape while I was at work. Eventually my work became more flexible, and I started to bring Loki to the office. This went on for quite awhile, with my few coworkers being more than pleased to have a fuzzy stress reliever roaming around.

Then one Thursday, my superiors told me that Loki could no longer come to work with me. The idea of leaving Loki alone again was no longer about his bad tendencies, but rather my preference to not be apart. So I submitted my resignation on Friday. I didn't like being chained to that desk anyway.

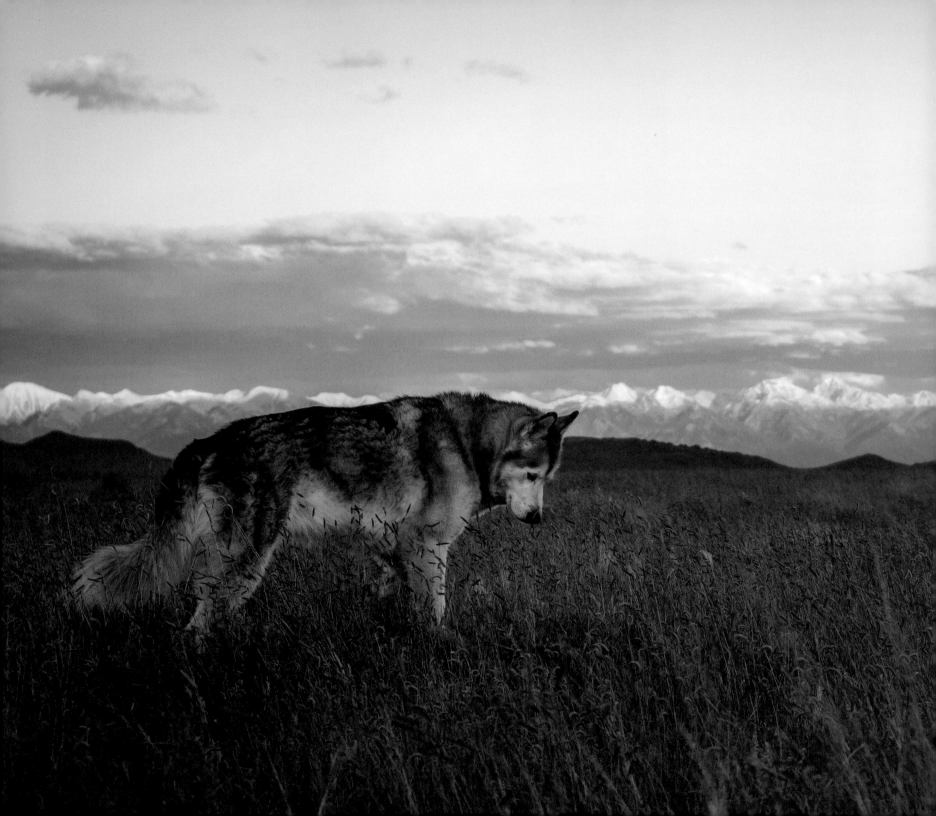

Dog Is Not a Crime

When people ask us how we find the places we camp or travel to, I rarely answer them openly because the conversation is so much larger.

We drive by a lot of places we would love to see and spend time at. But the reality of the situation is that Loki is not allowed a lot of places. Nine times out of ten, we have to pass on a location because he can't technically leave the paved concrete parking lot.

In the spirit of wanting to keep moving, we try not to let it frustrate us because it does push us to keep exploring. Often times we end up driving ten times farther than intended. Even more often I am digging through maps to find uncommon places. At the end of the day, I am grateful that we aren't somewhere with one hundred strangers and a guardrail subtly telling us to leave.

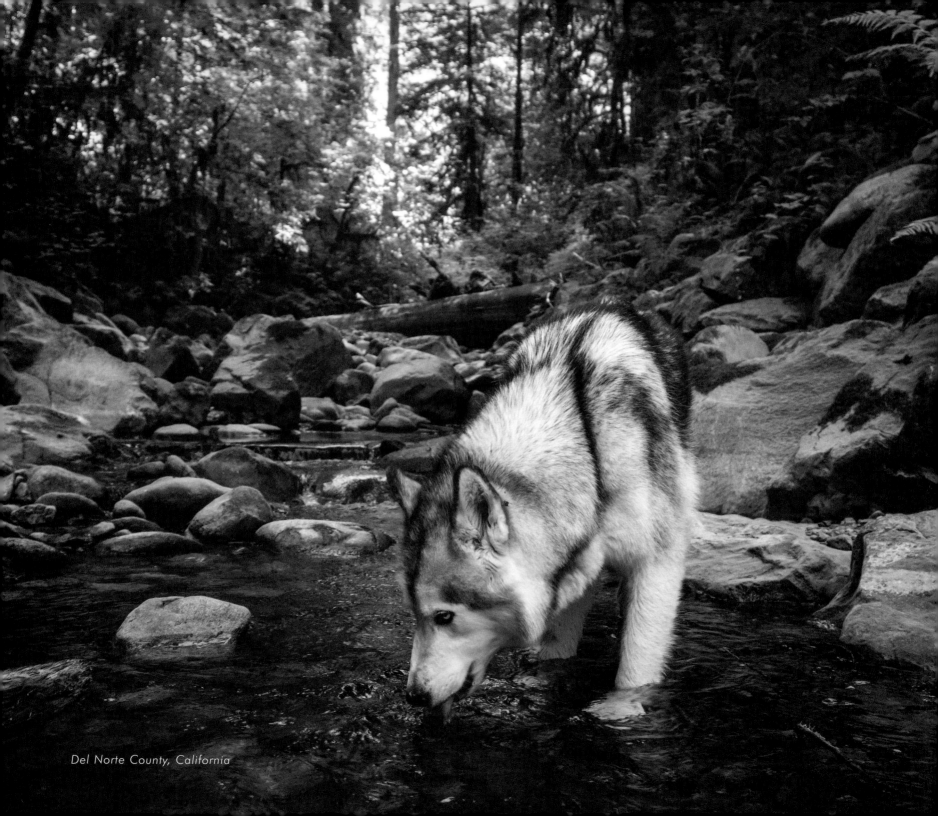

Del Norte County, California

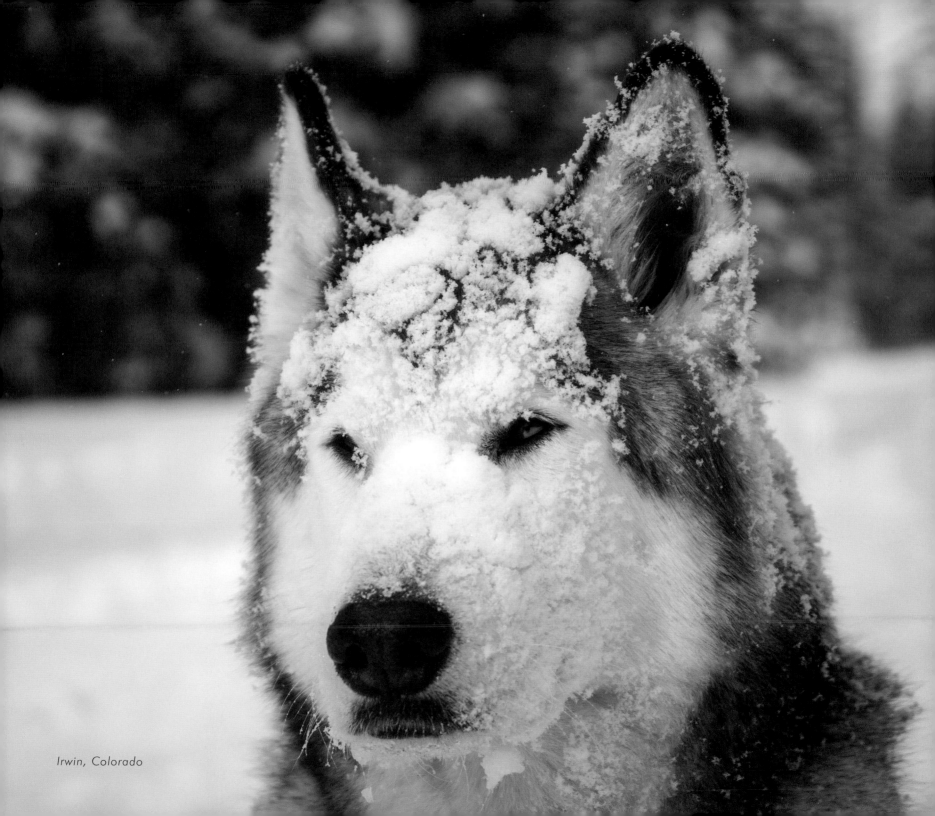

Irwin, Colorado

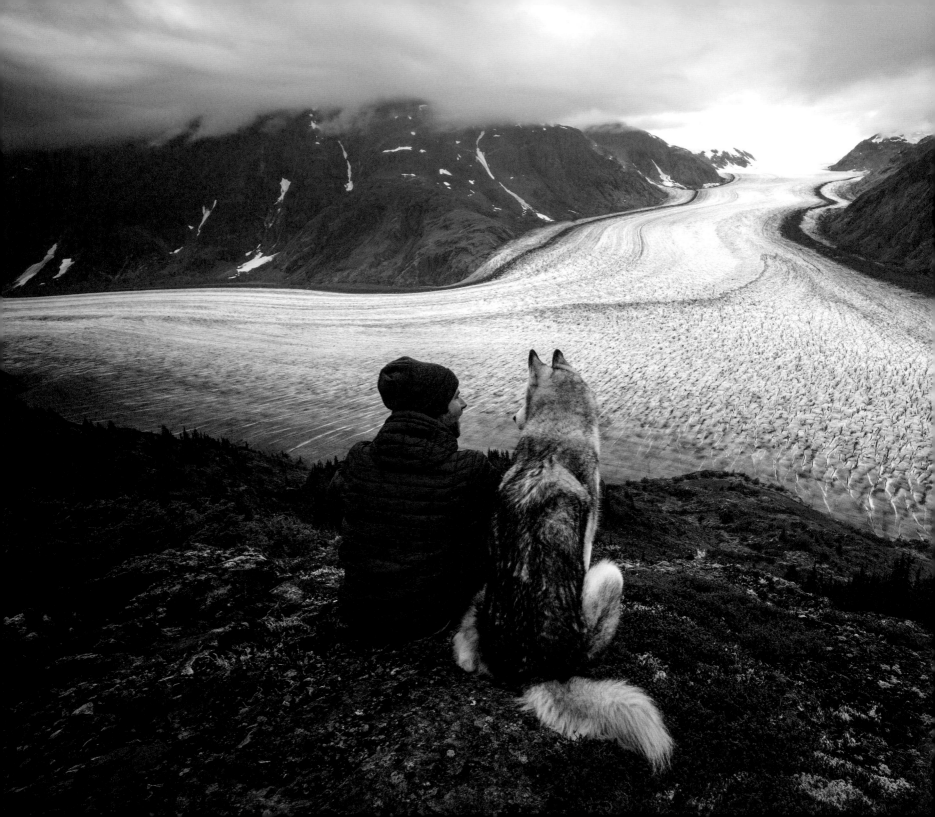

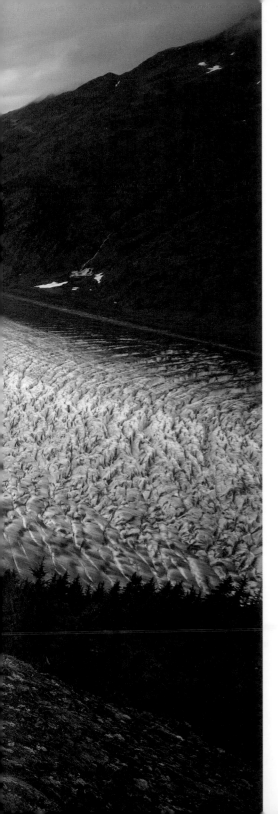

Forget Me Not

I am not sure what constitutes a memory. The ins and outs, the whos, hows, and whys of our memory bank; it is a complexity that rivals the galaxies in space. Loki and I have explored so many places and been fortunate enough to do so. We get to have memories that are as common as any other human-dog relationship, but I recognize we have opportunities to experience things that not everyone gets.

Insert photography, which has allowed me to remember even more. I can pinpoint a moment in a matter of seconds, and my mind and heart can be teleported back. All these memories turned into photographs, it has challenged me to become a storyteller.

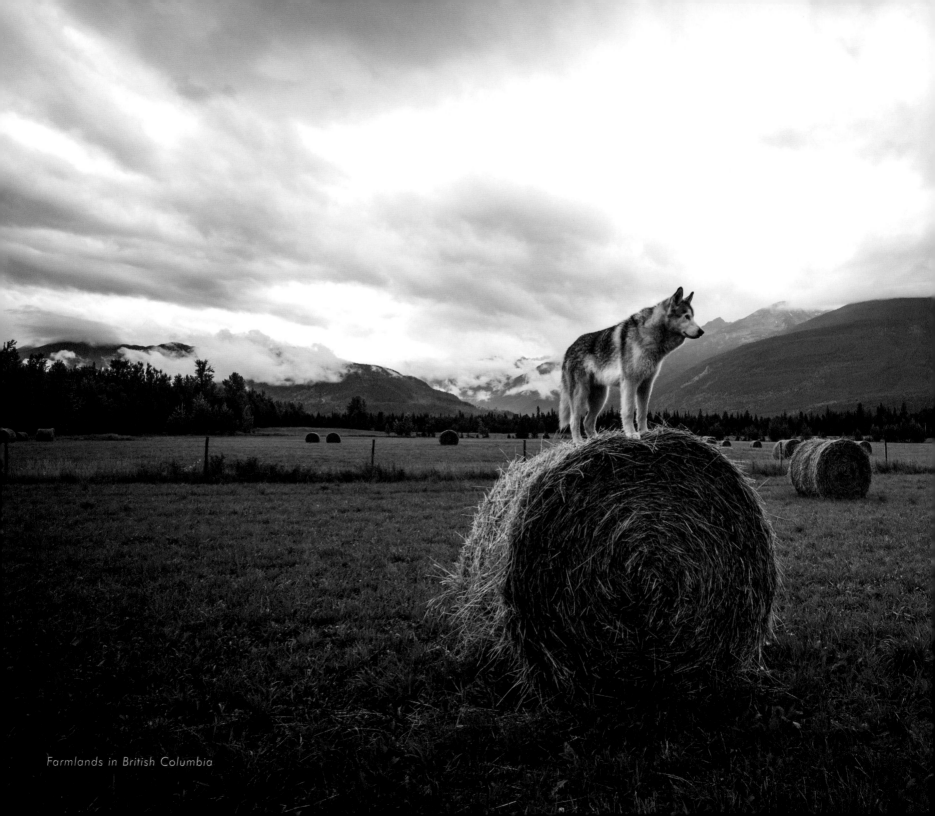

Farmlands in British Columbia

Wild Thing, you make my heart sing.

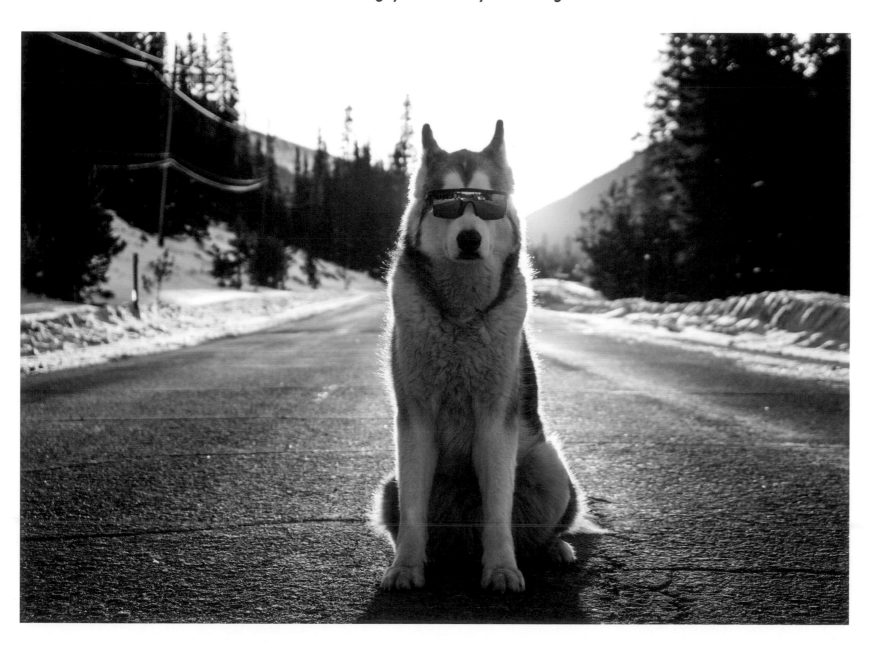

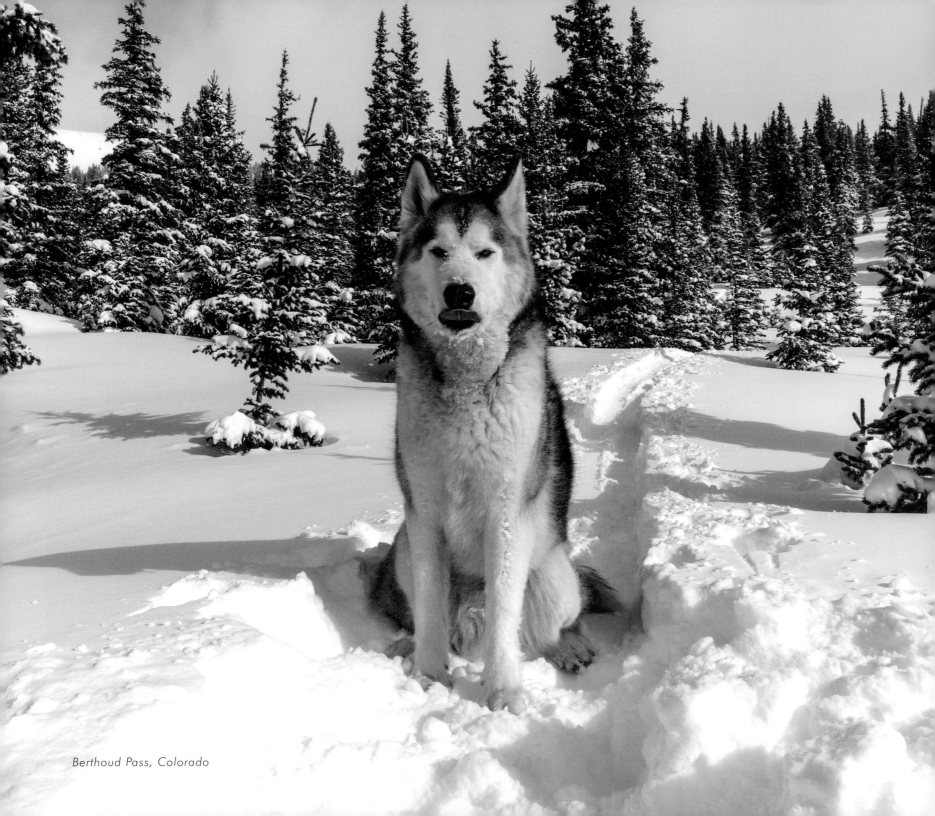

Berthoud Pass, Colorado

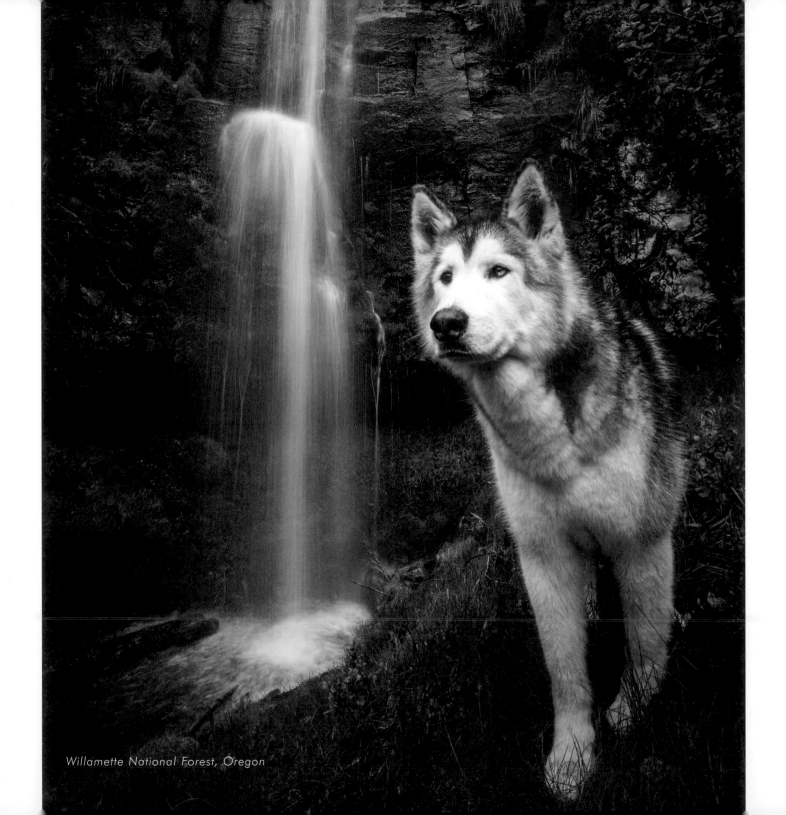

Willamette National Forest, Oregon

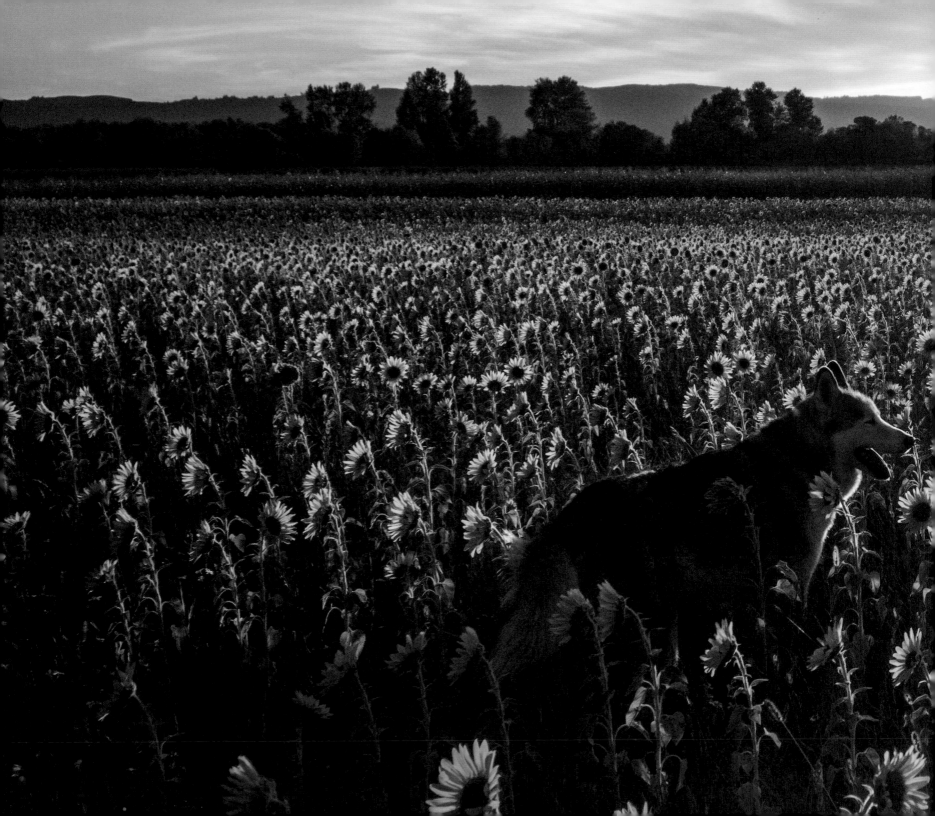

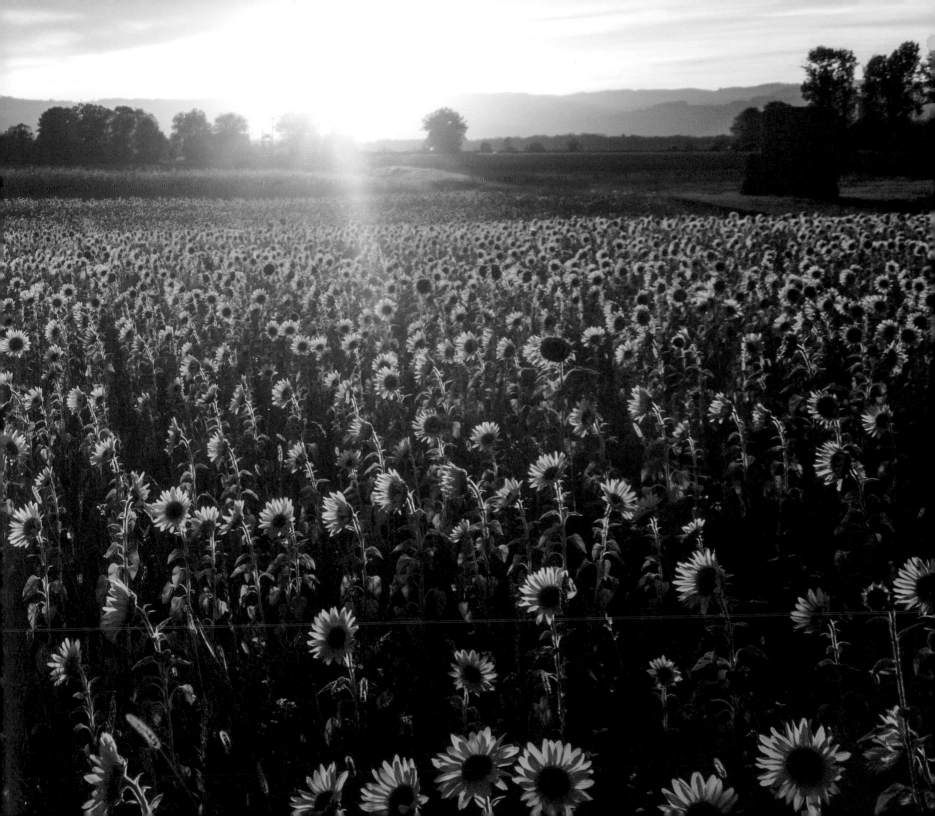

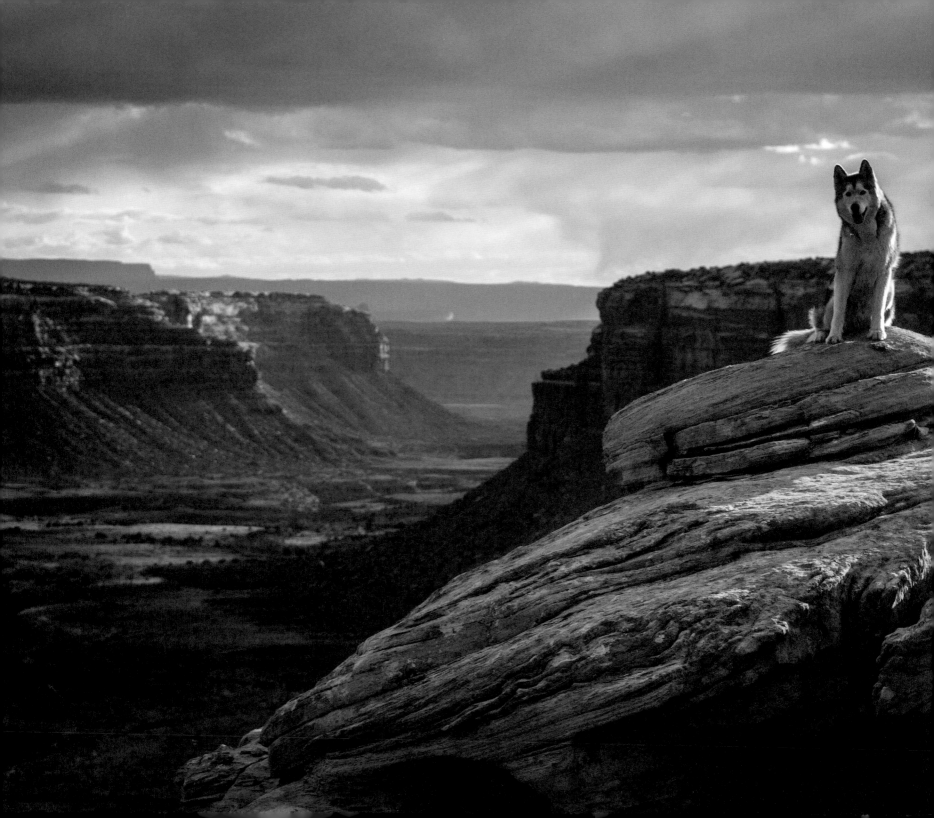

While You May Go

The thought of independence has always been interesting to me. Loki has never needed me to explore. It has been engrained in him from birth to want to roam. There are these moments I watch him move independently from me, not giving a second thought to where I may be going, and I am reminded that he does not need me. It can bring on the sharp sting of loneliness at times, especially so when we are deep in the woods miles from anything. I don't know what he is thinking or why his pace quickens away from mine. I don't know where he wants to go or if he wants me there with him. Having a dog like Loki, who seems to be a more decisive being than myself, has forced me to explore these depths of uncertainties.

I remind myself that he chooses to come back; he chooses to find me again when he feels ready or if I call out for him. I wonder if the sense of loneliness creeps into his heart, too. He is the dog he is because I allow him that freedom. I think we understand each other; "While you may go, your home is here with me." In this, he has taught me more about trust than anything else.

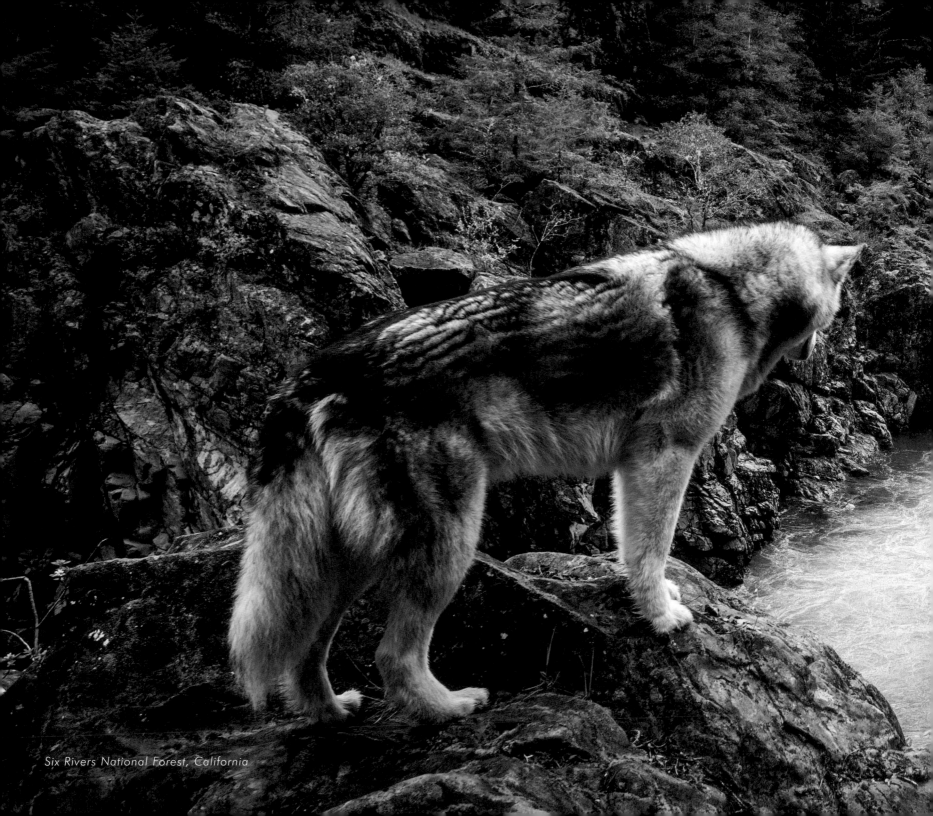

Six Rivers National Forest, California

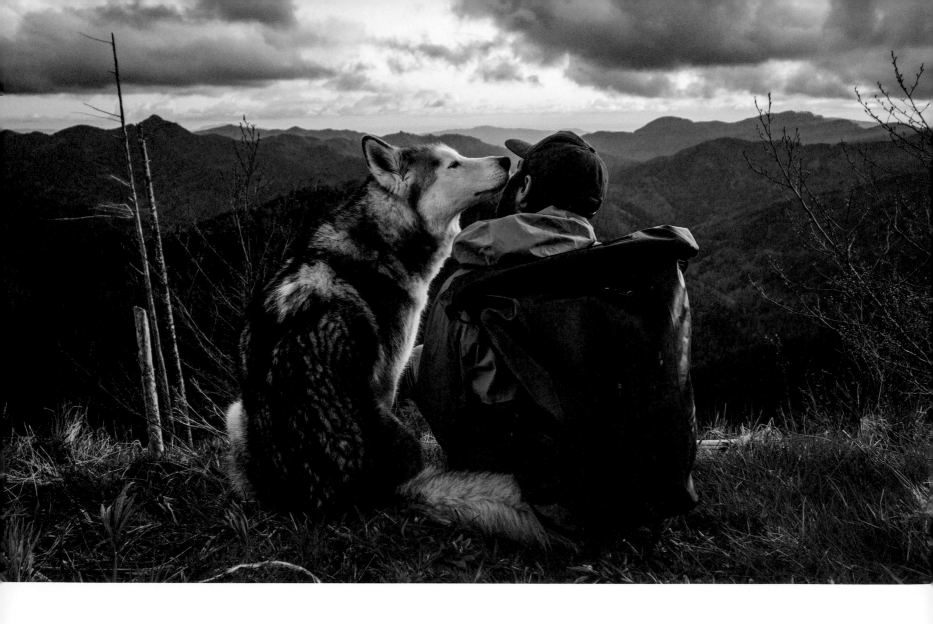

One day, I will measure my life through these memories with him.

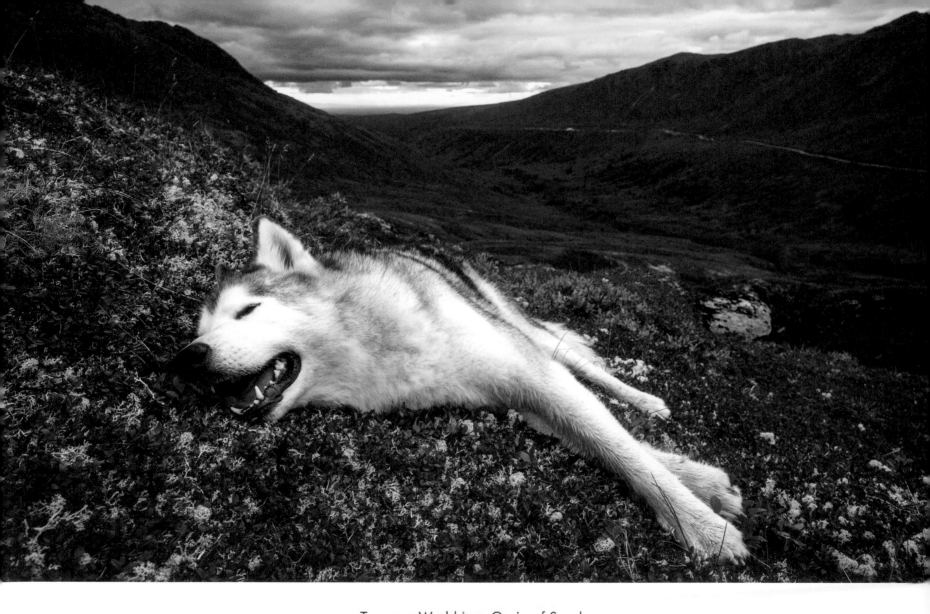

To see a World in a Grain of Sand
And Heaven in a Wild Flower
Hold Infinity in the palm of your hand
And Eternity in an hour
—William Blake, "Auguries of Innocence"

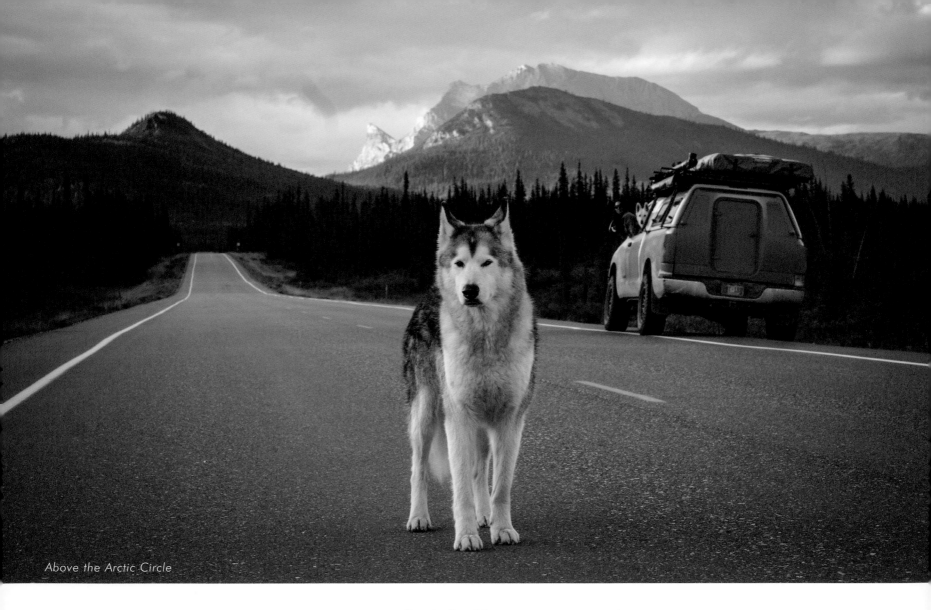

Above the Arctic Circle

Don't Go Alone

For me, it has to be about far more than just taking photos of Loki. We want to show others what you really can experience with your dog. The memories that can be made together are endless, and you don't have to leave them behind.

If we are remembered for anything, I hope it is that we inspired others to get to the great outdoors with their pup.